Unpacking My Library

Unpacking My Library: Architects and Their Books

Edited by Jo Steffens
Featuring an Essay by Walter Benjamin

Yale University Press, New Haven and London

in association with
Urban Center Books, The Architecture Bookstore of the Municipal Art Society of New York

This book has been published in conjunction with the exhibition *Unpacking My Library*, which opened at The Urban Center in May 2009. A series of conversations between the participating architects took place over the course of the exhibition. The exhibit, interviews, and conversations are available at urbancenterbooks.org.

Unpacking My Library was made possible by a grant from Elise Jaffe + Jeffrey Brown.

Yale University Press
Senior Editor, Art and Architecture: Michelle Komie
Manuscript Editor: Jenya Weinreb
Production Manager: Ken Wong

Urban Center Books
Director and Editor: Jo Steffens
Conceptual Design: Matthias Neumann
Photographer: Carlos Solis
Editorial Adviser: GK/Agence "X"

Designed by Michael Bierut and Yve Ludwig, Pentagram Design.
Set in Mercury by Hoefler & Frere-Jones and Apex New by Chester Jenkins.
Printed in China by Anderson International Printing Group.

Library of Congress Cataloging-in-Publication Data is found at the end of this book.

A catalogue record for this book is available from the British Library.

This paper meets the requirements of ANSI/NISO Z39.48–1992 (Permanence of Paper).

10 9 8 7 6 5 4 3

Contents

Preface

Architecture will no longer be the social, the collective, the dominant art. The great poem, the great building, the great work of mankind will no longer be built, it will be printed.
—Victor Hugo

In a talk on book collecting at Cooper Union in 2006, Beatriz Colomina gave an intimate account of the books she packed and unpacked during her first move to New York. Her presentation, the inspiration for this project, led us to the original version of "Unpacking My Library," Walter Benjamin's essay in his book *Illuminations,* and that essay, in turn, gave us the idea to photograph and exhibit architects' libraries.

Although the project began as an exhibition, the book *Unpacking My Library* is free of the physical and temporal limitations of an installation. Books have a quality of permanence, which in part explains our fascination with them. Lars Müller, a publisher and designer, took on a project in the same spirit when he published *Le Corbusier, Architect of Books* (2006). Müller stated: "There is a responsibility, if you are to design something that is meant to last. That brings the book close to architecture, because architecture is meant to last, and before it comes to form it comes to function."

Unpacking My Library has appeal beyond the world of architecture, for it affirms the importance

of books in our lives. As you browse the books shown in these pages, a familiar title will spark recognition; an idea or conversation may be recalled. Not unlike Proust's famous madeleine, books are laden with powerful associations, and through them we share common histories and develop personal relationships.

Each architect's collection is unique and informs its owner's practice in surprising ways. Tod Williams and Billie Tsien's library, for example, is remarkable for its archaeological and literary aesthetic, while Liz Diller and Ric Scofidio's library is imbued with a techno-eclectic and pop-cultural sensibility. The images of each library are accompanied by an interview with its owner and a list of that architect's ten most recommended books. Through the architects' interviews and lists we gain an understanding of how their reading and collecting influence their professional practice and personal lives.

We chose our participants for their variety of styles and approaches to their discipline. We also specifically targeted architects who were renowned for their personal and professional libraries. (Peter Eisenman, for example, has donated the bulk of his collection of rare modernist publications to Yale University's Beinecke Rare Book and Manuscript Library.) While the bias toward New York architects might be perceived as a form of myopia, it was instead a strategic decision in favor of the always-important recognition of what is at hand.

Unpacking My Library has the potential to serve as an invaluable snapshot of the discipline of architecture at the beginning of the twenty-first century. This book captures a representative cross-section of these notable libraries, mapping the intellectual and emotional terrain of present-day architects and scholars. Only apparently retrospective, this project in fact looks to archi–tecture's future through the lens of the present, showing, as Victor Hugo noted, that architecture and the book share a common agenda.

—Jo Steffens

Unpacking My Library: A Talk about Book Collecting
by Walter Benjamin

I AM UNPACKING MY LIBRARY. Yes, I am. The books are not yet on the shelves, not yet touched by the mild boredom of order. I cannot march up and down their ranks to pass them in review before a friendly audience. You need not fear any of that. Instead, I must ask you to join me in the disorder of crates that have been wrenched open, the air saturated with the dust of wood, the floor covered with torn paper, to join me among piles of volumes that are seeing daylight again after two years of darkness, so that you may be ready to share with me a bit of the mood—it is certainly not an elegiac mood but, rather, one of anticipation—which these books arouse in a genuine collector. For such a man is speaking to you, and on closer scrutiny he proves to be speaking only about himself. Would it not be presumptuous of me if, in order to appear convincingly objective and down-to-earth, I enumerated for you the main sections or prize pieces of a library, if I presented you with their history or even

their usefulness to a writer? I, for one, have in mind something less obscure, something more palpable than that; what I am really concerned with is giving you some insight into the relationship of a book collector to his possessions, into collecting rather than a collection. If I do this by elaborating on the various ways of acquiring books, this is something entirely arbitrary. This or any other procedure is merely a dam against the spring tide of memories which surges toward any collector as he contemplates his possessions. Every passion borders on the chaotic, but the collector's passion borders on the chaos of memories. More than that: the chance, the fate, that suffuse the past before my eyes are conspicuously present in the accustomed confusion of these books. For what else is this collection but a disorder to which habit has accommodated itself to such an extent that it can appear as order? You have all heard of people whom the loss of their books has turned into invalids, or of those who in order to acquire them became criminals. These are the very areas in which any order is a

balancing act of extreme precariousness. "The only exact knowledge there is," said Anatole France, "is the knowledge of the date of publication and the format of books." And indeed, if there is a counterpart to the confusion of a library, it is the order of its catalogue.

Thus there is in the life of a collector a dialectical tension between the poles of disorder and order. Naturally, his existence is tied to many other things as well: to a very mysterious relationship to ownership, something about which we shall have more to say later; also, to a relationship to objects which does not emphasize their functional, utilitarian value—that is, their usefulness—but studies and loves them as the scene, the stage, of their fate. The most profound enchantment for the collector is the locking of individual items within a magic circle in which they are fixed as the final thrill, the thrill of acquisition, passes over them. Everything remembered and thought, everything conscious, becomes the pedestal, the frame, the base, the lock of his property. The period, the region, the craftsmanship, the former ownership—for a true collector the whole background of an item adds up to a magic encyclopedia whose quintessence is the fate of his object. In this circumscribed area, then, it may be surmised how the great physiognomists—and collectors are the physiognomists of the world of objects—turn into interpreters of fate. One has only to watch a collector handle the objects in his glass case. As he holds them in his hands, he seems to be seeing through them into their distant past as though inspired. So much for the magical side of the collector—his old-age image, I might call it.

Habent sua fata libelli: these words may have been intended as a general statement about books. So books like *The Divine Comedy,* Spinoza's *Ethics,* and *The Origin of Species* have their fates. A collector, however, interprets this Latin saying differently. For him, not only books but also copies of books have their fates. And in this sense, the most important fate of a copy is its encounter with him, with his own collection. I am not exaggerating when I say that to a true collector the acquisition

of an old book is its rebirth. This is the childlike element which in a collector mingles with the element of old age. For children can accomplish the renewal of existence in a hundred unfailing ways. Among children, collecting is only one process of renewal; other processes are the painting of objects, the cutting out of figures, the application of decals—the whole range of childlike modes of acquisition, from touching things to giving them names. To renew the old world—that is the collector's deepest desire when he is driven to acquire new things, and that is why a collector of older books is closer to the wellsprings of collecting than the acquirer of luxury editions. How do books cross the threshold of a collection and become the property of a collector? The history of their acquisition is the subject of the following remarks.

Of all the ways of acquiring books, writing them oneself is regarded as the most praiseworthy method. At this point many of you will remember with pleasure the large library which Jean Paul's poor little schoolmaster Wutz gradually acquired by writing, himself, all the works whose titles interested him in book-fair catalogues; after all, he could not afford to buy them. Writers are really people who write books not because they are poor, but because they are dissatisfied with the books which they could buy but do not like. You, ladies and gentlemen, may regard this as a whimsical definition of a writer. But everything said from the angle of a real collector is whimsical. Of the customary modes of acquisition, the one most appropriate to a collector would be the borrowing of a book with its attendant non-returning. The book borrower of real stature whom we envisage here proves himself to be an inveterate collector of books not so much by the fervor with which he guards his borrowed treasures and by the deaf ear which he turns to all reminders from the everyday world of legality as by his failure to read these books. If my experience may serve as evidence, a man is more likely to return a borrowed book upon occasion than to read it. And the non-reading of books, you will object, should be characteristic of

collectors? This is news to me, you may say. It is not news at all. Experts will bear me out when I say that it is the oldest thing in the world. Suffice it to quote the answer which Anatole France gave to a philistine who admired his library and then finished with the standard question, "And you have read all these books, Monsieur France?" "Not one-tenth of them. I don't suppose you use your Sèvres china every day?"

Incidentally, I have put the right to such an attitude to the test. For years, for at least the first third of its existence, my library consisted of no more than two or three shelves which increased only by inches each year. This was its militant age, when no book was allowed to enter it without the certification that I had not read it. Thus I might never have acquired a library extensive enough to be worthy of the name if there had not been an inflation. Suddenly the emphasis shifted; books acquired real value, or, at any rate, were difficult to obtain. At least this is how it seemed in Switzerland. At the eleventh hour I sent my first major book orders from there and in this way was able to secure such irreplaceable items as *Der blaue Reiter* and Bachofen's *Sage von Tanaquil,* which could still be obtained from the publishers at that time.

Well—so you may say—after exploring all these byways we should finally reach the wide highway of book acquisition, namely, the purchasing of books. This is indeed a wide highway, but not a comfortable one. The purchasing done by a book collector has very little in common with that done in a bookshop by a student getting a textbook, a man of the world buying a present for his lady, or a businessman intending to while away his next train journey. I have made my most memorable purchases on trips, as a transient. Property and possession belong to the tactical sphere. Collectors are people with a tactical instinct; their experience teaches them that when they capture a strange city, the smallest antique shop can be a fortress, the most remote stationery store a key position. How many cities have revealed themselves to me in the marches I undertook in the pursuit of books!

By no means all of the most important purchases are made on the premises of a dealer. Catalogues play a far greater part. And even though the purchaser may be thoroughly acquainted with the book ordered from a catalogue, the individual copy always remains a surprise and the order always a bit of a gamble. There are grievous disappointments, but also happy finds. I remember, for instance, that I once ordered a book with colored illustrations for my old collection of children's books only because it contained fairy tales by Albert Ludwig Grimm and was published at Grimma, Thuringia. Grimma was also the place of publication of a book of fables edited by the same Albert Ludwig Grimm. With its sixteen illustrations my copy of this book of fables was the only extant example of the early work of the great German book illustrator Lyser, who lived in Hamburg around the middle of the last century. Well, my reaction to the consonance of the names had been correct. In this case too I discovered the work of Lyser, namely *Linas Märchenbuch,* a work which has remained unknown to his bibliographers and which deserves a more detailed reference than this first one I am introducing here.

The acquisition of books is by no means a matter of money or expert knowledge alone. Not even both factors together suffice for the establishment of a real library, which is always somewhat impenetrable and at the same time uniquely itself. Anyone who buys from catalogues must have flair in addition to the qualities I have mentioned. Dates, place names, formats, previous owners, bindings, and the like: all these details must tell him something—not as dry, isolated facts, but as a harmonious whole; from the quality and intensity of this harmony he must be able to recognize whether a book is for him or not. An auction requires yet another set of qualities in a collector. To the reader of a catalogue the book itself must speak, or possibly its previous ownership if the provenance of the copy has been established. A man who wishes to participate at an auction must pay equal attention to the book and to his

competitors, in addition to keeping a cool enough head to avoid being carried away in the competition. It is a frequent occurrence that someone gets stuck with a high purchase price because he kept raising his bid—more to assert himself than to acquire the book. On the other hand, one of the finest memories of a collector is the moment when he rescued a book to which he might never have given a thought, much less a wishful look, because he found it lonely and abandoned on the market place and bought it to give it its freedom—the way the prince bought a beautiful slave girl in *The Arabian Nights*. To a book collector, you see, the true freedom of all books is somewhere on his shelves.

To this day, Balzac's *Peau de chagrin* stands out from long rows of French volumes in my library as a memento of my most exciting experience at an auction. This happened in 1915 at the Rümann auction put up by Emil Hirsch, one of the greatest of book experts and most distinguished of dealers. The edition in question appeared in 1838 in Paris, Place de la Bourse. As I pick up my copy, I see not only its number in the Rümann collection, but even the label of the shop in which the first owner bought the book over ninety years ago for one-eightieth of today's price. "Papeterie I. Flanneau," it says. A fine age in which it was still possible to buy such a de luxe edition at a stationery dealer's! The steel engravings of this book were designed by the foremost French graphic artist and executed by the foremost engravers. But I was going to tell you how I acquired this book. I had gone to Emil Hirsch's for an advance inspection and had handled forty or fifty volumes; that particular volume had inspired in me the ardent desire to hold on to it forever. The day of the auction came. As chance would have it, in the sequence of the auction this copy of *La Peau de chagrin* was preceded by a complete set of its illustrations printed separately on India paper. The bidders sat at a long table; diagonally across from me sat the man who was the focus of all eyes at the first bid, the famous Munich collector Baron von Simolin. He was greatly interested in this set, but he had rival bidders; in short,

there was a spirited contest which resulted in the highest bid of the entire auction—far in excess of three thousand marks. No one seemed to have expected such a high figure, and all those present were quite excited. Emil Hirsch remained unconcerned, and whether he wanted to save time or was guided by some other consideration, he proceeded to the next item, with no one really paying attention. He called out the price, and with my heart pounding and with the full realization that I was unable to compete with any of those big collectors I bid a somewhat higher amount. Without arousing the bidders' attention, the auctioneer went through the usual routine—"Do I hear more?" and three bangs of his gavel, with an eternity seeming to separate each from the next—and proceeded to add the auctioneer's charge. For a student like me the sum was still considerable. The following morning at the pawnshop is no longer part of this story, and I prefer to speak about another incident which I should like to call the negative of an auction. It happened last year at a Berlin auction.

The collection of books that was offered was a miscellany in quality and subject matter, and only a number of rare works on occultism and natural philosophy were worthy of note. I bid for a number of them, but each time I noticed a gentleman in the front row who seemed only to have waited for my bid to counter with his own, evidently prepared to top any offer. After this had been repeated several times, I gave up all hope of acquiring the book which I was most interested in that day. It was the rare *Fragmente aus dem Nachlass eines jungen Physikers* [Posthumous Fragments of a Young Physicist] which Johann Wilhelm Ritter published in two volumes at Heidelberg in 1810. This work has never been reprinted, but I have always considered its preface, in which the author-editor tells the story of his life in the guise of an obituary for his supposedly deceased unnamed friend—with whom he is really identical—as the most important sample of personal prose of German Romanticism. Just as the item came up I had a brain wave. It was simple enough: since my bid was bound to give

the item to the other man, I must not bid at all. I controlled myself and remained silent. What I had hoped for came about: no interest, no bid, and the book was put aside. I deemed it wise to let several days go by, and when I appeared on the premises after a week, I found the book in the secondhand department and benefited by the lack of interest when I acquired it.

Once you have approached the mountains of cases in order to mine the books from them and bring them to the light of day—or, rather, of night—what memories crowd in upon you! Nothing highlights the fascination of unpacking more clearly than the difficulty of stopping this activity. I had started at noon, and it was midnight before I had worked my way to the last cases. Now I put my hands on two volumes bound in faded boards which, strictly speaking, do not belong in a book case at all: two albums with stick-in pictures which my mother pasted in as a child and which I inherited. They are the seeds of a collection of children's books which is growing steadily even today, though no longer in my garden. There is no living library that does not harbor a number of book-like creations from fringe areas. They need not be stick-in albums or family albums, autograph books or portfolios containing pamphlets or religious tracts; some people become attached to leaflets and prospectuses, others to handwriting facsimiles or typewritten copies of unobtainable books; and certainly periodicals can form the prismatic fringes of a library. But to get back to those albums: Actually, inheritance is the soundest way of acquiring a collection. For a collector's attitude toward his possessions stems from an owner's feeling of responsibility toward his property. Thus it is, in the highest sense, the attitude of an heir, and the most distinguished trait of a collection will always be its transmissibility. You should know that in saying this I fully realize that my discussion of the mental climate of collecting will confirm many of you in your conviction that this passion is behind the times, in your distrust of the collector type. Nothing is further from my mind than to shake

either your conviction or your distrust. But one thing should be noted: the phenomenon of collecting loses its meaning as it loses its personal owner. Even though public collections may be less objectionable socially and more useful academically than private collections, the objects get their due only in the latter. I do know that time is running out for the type that I am discussing here and have been representing before you a bit *ex officio*. But, as Hegel put it, only when it is dark does the owl of Minerva begin its flight. Only in extinction is the collector comprehended.

Now I am on the last half-emptied case and it is way past midnight. Other thoughts fill me than the ones I am talking about—not thoughts but images, memories. Memories of the cities in which I found so many things: Riga, Naples, Munich, Danzig, Moscow, Florence, Basel, Paris; memories of Rosenthal's sumptuous rooms in Munich, of the Danzig Stockturm where the late Hans Rhaue was domiciled, of Süssengut's musty book cellar in North Berlin; memories of the rooms where these books had been housed, of my student's den in Munich, of my room in Bern, of the solitude of Iseltwald on the Lake of Brienz, and finally of my boyhood room, the former location of only four or five of the several thousand volumes that are piled up around me. O bliss of the collector, bliss of the man of leisure! Of no one has less been expected, and no one has had a greater sense of well-being than the man who has been able to carry on his disreputable existence in the mask of Spitzweg's "Bookworm." For inside him there are spirits, or at least little genii, which have seen to it that for a collector—and I mean a real collector, a collector as he ought to be—ownership is the most intimate relationship that one can have to objects. Not that they come alive in him; it is he who lives in them. So I have erected one of his dwellings, with books as the building stones, before you, and now he is going to disappear inside, as is only fitting.

Architects and Their Books

Stan Allen

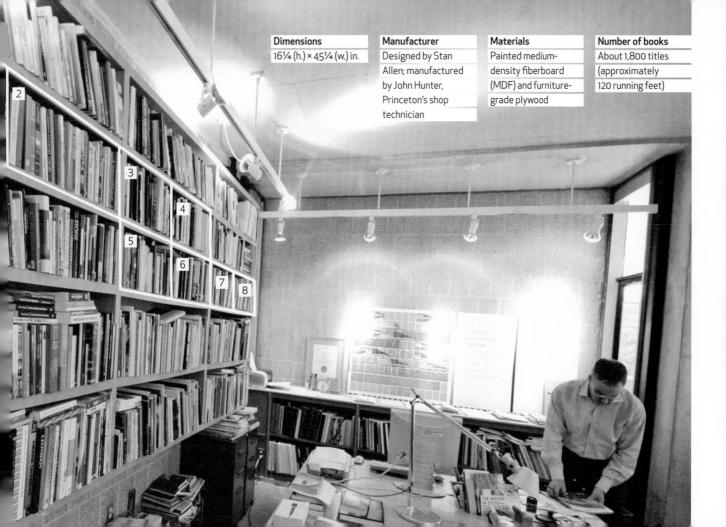

Dimensions
16¼ (h.) × 45¼ (w.) in.

Manufacturer
Designed by Stan
Allen; manufactured
by John Hunter,
Princeton's shop
technician

Materials
Painted medium-
density fiberboard
(MDF) and furniture-
grade plywood

Number of books
About 1,800 titles
(approximately
120 running feet)

Stan Allen: I have consistently maintained that architecture is a *material practice*—that is to say, it works in and among the world of things. Architectural practice has a unique capacity to transform matter and add something new to the world. But it's also true that these translations between drawing and building today take place within a larger flow of images and ideas. I would propose that the exercise of what Michael Speaks has termed *design intelligence* is necessary today to navigate effectively in this new, information-dense context. Speaks's formulation plays on two meanings of the word *intelligence*. On the one hand, it recognizes that architects possess a specific form of expertise, a synthetic and projective capacity unique to their own discipline. Design intelligence in this sense implies the thoughtful application of that expertise to problems specific to architecture. On the other hand, just as military intelligence is composed of rumors and fragmented information, often from suspect sources (a high noise-to-signal ratio), it implies that architects need to be open to the "chatter" of the world outside their own field.

As in intelligence work, with immense quantities of information now simultaneously available, it is no longer access to information that counts, but rather the ability to process, organize, and visualize information that is crucial.

The somewhat eclectic reading list I proposed represents a cross-section of my own personal design intelligence, such as it is. There are classic architectural texts (by Reyner Banham, Robin Evans, and Robert Venturi), two novels, and essays by Gregory Bateson and John Brinckerhoff Jackson that underscore the importance of landscape and ecology in my recent thinking. I've included Dave Hickey's essay collection *Air Guitar*, and a little-known book by Jane Jacobs, *Systems of Survival*, first recommended to me by Dave Hickey. Jane Jacobs and Dave Hickey…who knew? Perhaps that's enough to motivate people to read both more closely.

Urban Center Books: You have on your bookshelves quite a few books on what has come to be called critical theory versus history per se, and one notes here works by Walter Benjamin, Terry Eagleton, Manfredo Tafuri, Fredric Jameson, and Slavoj Žižek in particular, plus art-historical books on Dada and Surrealism. Given the presence of books by Yve-Alain Bois, Rosalind Krauss, and Hal Foster, it seems natural to ask about the significance of these books for you.

A library is a cut across fields of knowledge, but it also records time, and changing ideas in the discipline. The books you mention belong to a period when architecture was deeply engaged in philosophy, borrowing concepts from a wide range of sources and, in particular, pursuing the linguistic analogy as a way to understand architecture and other forms of cultural production. Those ideas were very significant at the time, but they did their work; they got the field to another place. Today I would be more likely to argue that architecture's own history, its own objects and procedures, is capable of sustaining dense argument without recourse to concepts from outside the field.

On the other hand, my interest in painting and sculpture has been pretty consistent. I am married

to an artist, and the first projects I ever built as an architect were a series of art galleries in New York. I continue to learn from the art world. In the office we are as likely to refer to painters as architects, and my bookshelves at home are filled with art books. The art world is a big place, and it generates a lot of discourse. There is a huge range, and a kind of intellectual agility that you don't often find in architecture writing (someone like Dave Hickey comes to mind). Interestingly enough, the art world today is very interested in architecture. Rosalind Krauss appears regularly on architecture reading lists, and that is in part the basis of our close working relationship with Hal Foster and Princeton's Department of Art and Archaeology.

Is it cyclical, this emphasis on scholarly work—the reading and the writing? This is interesting in the sense that it seems almost overwhelming. How do you choose what to read?

Most of my reading today is directed—that is to say, a particular piece I am writing or a course I am teaching requires me to track something down, whether it is Gregory Bateson on ecology, Bruno Latour on science, or the Smithsons on the "as found" (the ordinary). My own writing is, for better or worse, driven by references; I need those scraps of quotation to build on, to try and say something more or less original beginning from something found.

How much of this appetite for books, for reading and collecting, is present in the current generation of architecture students?

Hard to say; this generation gets information in different ways, and they are hungry in their own way. There is an immense amount of information available today. I think that for my generation, it was a question of actually getting access to the information in the first place. Today the problem

is more to determine what counts within this immense quantity of often-useless information.

Some might say that Stan Allen is a very rational, precise, yet sometimes poetic architect. Is there an important imaginative quality that transcends everyday practice?

I think that's accurate. I don't see these books as forming a kind of canon, or reinforcing rationality, but rather opening out to other possibilities, other worlds. It's the chance juxtapositions and random combinations that count.

ARCHITECTURE AND THE SCIENCES Picon and Ponte

Debord COMMENTS ON THE SOCIETY OF THE SPECTACLE GUY DEBORD

B & R

The Language of Images W. J. T. MITCHELL

Terry Eagleton LITERARY THEORY Minnesota Press

PICTURING MACHINES 1400–1700

de Certeau Heterologies Minnesota

MB 399

Andreas Huyssen AFTER THE GREAT DIVIDE Indiana

DADAS ON ART

The Essential FRANKFURT SCHOOL Reader CONTINUUM

RITES OF SPRING MODRIS EKSTEINS

KARL & ROSA ALFRED DÖBLIN FROMM

T. J. CLARK THE PAINTING OF MODERN LIFE PRINCETON

THE PAINTER OF MODERN LIFE BAUDELAIRE DA CAPO

André Breton What is SURREALISM? Edited and introduced by Franklin Rosemont

SURREALISM

MAD LOVE Chicago

CHANCE A Perspective on Dada Watts

The Politics of SURREALISM LEWIS PARAGON HOUSE

Hedges Languages of revolt Dada and surrealist literature and film Duke

ZOLA · THÉRÈSE RAQUIN

NADJA BY ANDRÉ BRETON

Nebraska André Breton

Communicating Vessels

COMPULSIVE BEAUTY FOSTER

Nadeau the history of SURREALISM Belknap Harvard

READINGS IN TWENTIETH CENTURY PHILOS

Book spines visible on the shelf (left to right):

- **KINO** A History of the Russian and Soviet Film — Leyda — PRINCETON
- **QUESTIONS OF CINEMA** — Stephen Heath — Indiana
- **MODERNIST MONTAGE** — P. ADAMS SITNEY
- **Shanghai Reflections** — STANFORD
- Glass
- **The Modern City** — JOEL KOTKIN
- **THE CITY** — Bazzler
- **BEHIND THE EXODUS** — LUC DELEU & T.O.P. OFFICE — MAGALI SAFFATI LAFSUN — MUHKA
- **GIEDION** SPACE, TIME and ARCHITECTURE — HARVARD
- Kwinter — **Architectures of Time**
- BANHAM — **A Critic Writes** ESSAYS BY REYNER BANHAM — CALIFORNIA
- **AGE OF THE MASTERS** Reyner Banham
- **S,M,L,XL** — THE MONACELLI PRESS
- The Presence of Mies
- **LEARNING FROM LAS VEGAS** — Venturi, Scott Brown, Izenour
- **The Museum of Modern Art** Papers on Architecture
- Alex Wall — **Victor Gruen** From Urban Shop to New City
- arc en rêve centre d'architecture — **MUTATIONS** — REM KOOLHAAS HARVARD PROJECT ON THE CITY / STEFANO BOERI MULTIPLICITY / SANFORD KWINTER / NADIA TAZI / HANS ULRICH OBRIST — ACTAR
- **OMA** / **6 PROJETS**
- Tschumi — une architecture en projet : Le Fresnoy
- **The Pelican History of Art** Architecture: Nineteenth and Twentieth Centuries — Henry-Russell Hitchcock
- **Urban Utopias in the Twentieth Century**

3

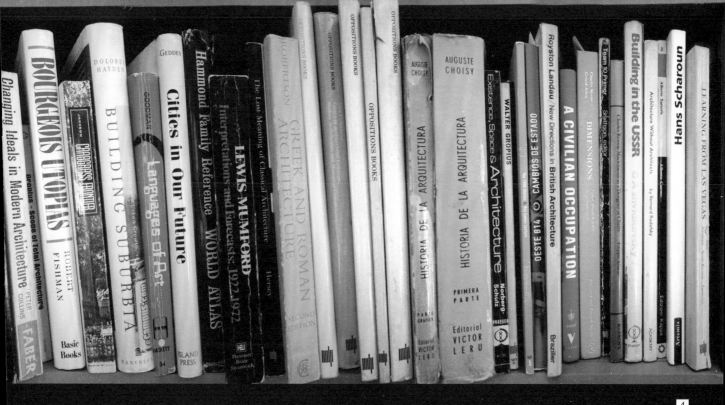

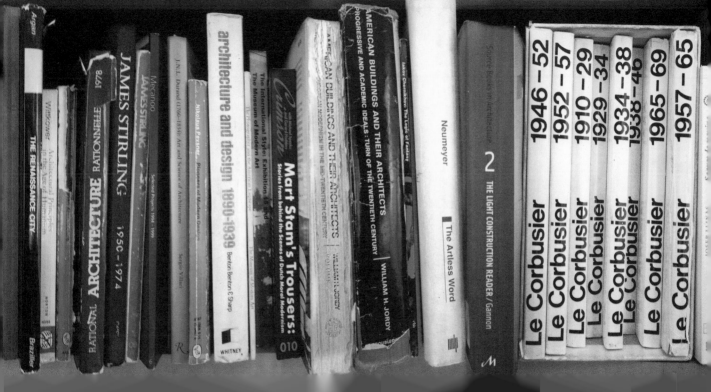

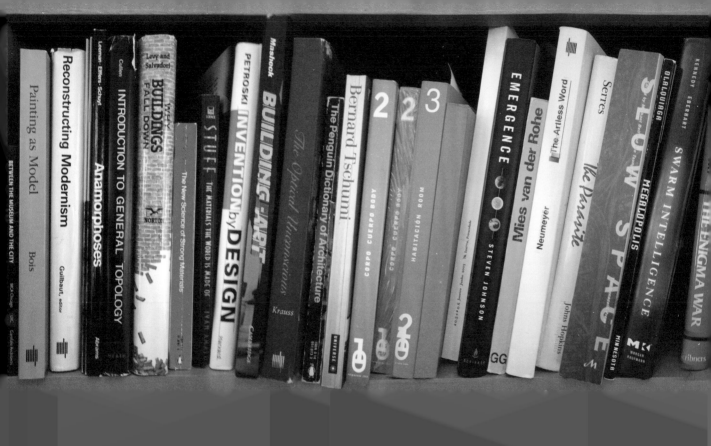

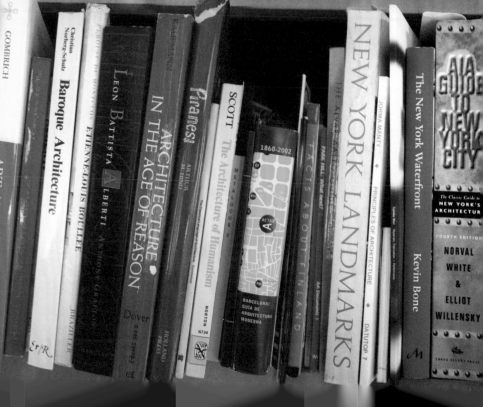

Top Ten Books
Stan Allen

Reyner Banham
*Theory and Design
in the First
Machine Age*

Gregory Bateson
*Steps to an
Ecology of Mind*

Robin Evans
*Translations from
Drawing to Building
and Other Essays*

Dave Hickey
*Air Guitar:
Essays on Art and
Democracy*

John Brinckerhoff
Jackson
*A Sense of Place,
A Sense of Time*

Jane Jacobs
*Systems of Survival:
A Dialogue on the
Moral Foundations
of Commerce
and Politics*

Stephen Kern
*The Culture of
Time and Space,
1880–1918*

Seicho Matsumoto
*Ten to sen
[Points and Lines]*

Thomas Pynchon
Gravity's Rainbow

Robert Venturi
*Complexity and
Contradiction
in Architecture*

THEORY AND
DESIGN
IN THE
FIRST
MACHINE
AGE REYNER
BANHAM

STEPS TO
AN ECOLOGY
OF MIND

GREGORY BATESON

One of the great books of the
20th century — Charles Bell

Translations from
Drawing to Building
and Other Essays

Robin Evans

AIR GUITAR

DAVE HICKEY

Essays on Art and Democracy

A Sense of PLACE, a Sense of TIME

"Altogether magnificent... Probably no single thinker has done
more to the last fifty years to transform our ideas about the
nature of urban life." — Chicago Tribune

SYSTEMS
OF
SURVIVAL

A Dialogue on the Moral
Foundations of Commerce and Politics

JANE JACOBS

author of
THE DEATH AND LIFE OF GREAT AMERICAN CITIES

THE CULTURE OF
TIME AND SPACE

1880 — 1918

STEPHEN KERN

KODANSHA

SEICHO
MATSUMOTO

POINTS
AND
LINES

Japan's classic best-selling mystery

GRAVITY'S
RAINBOW

THOMAS PYNCHON

COMPLEXITY
AND
CONTRADICTION
IN ARCHITECTURE

ROBERT VENTURI

Published by The Museum of Modern Art, New York in association with the Graham Foundation for Advanced Studies in the Fine Arts, Chicago

Henry N. Cobb

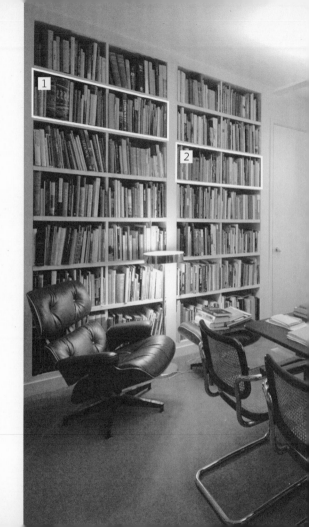

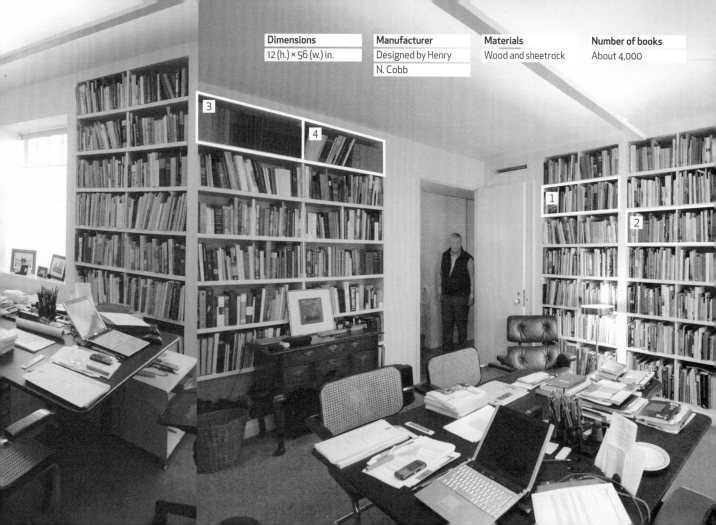

Dimensions	Manufacturer	Materials	Number of books
12 (h.) × 56 (w.) in.	Designed by Henry N. Cobb	Wood and sheetrock	About 4,000

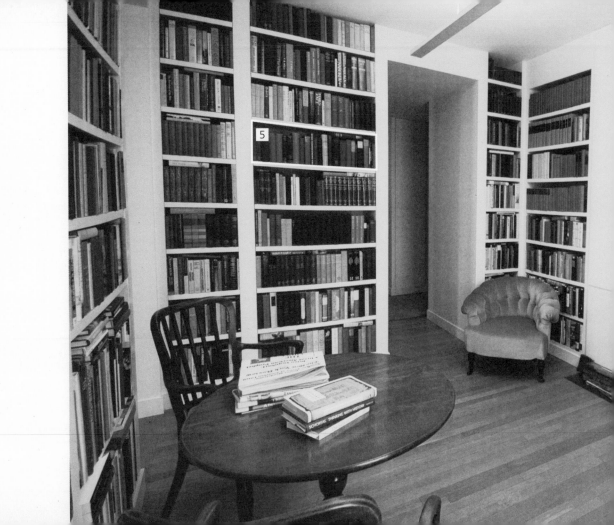

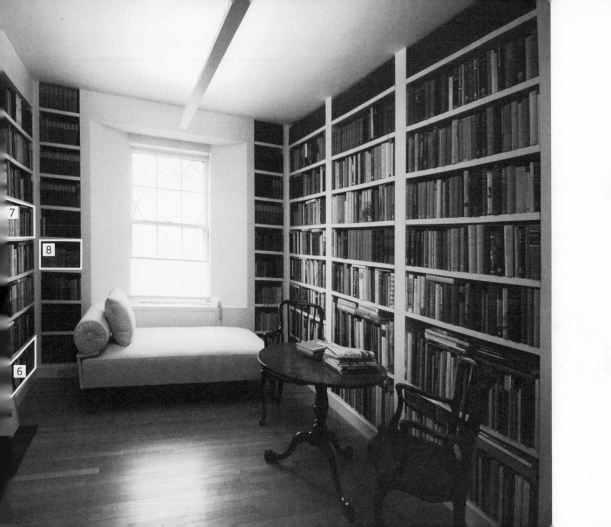

Urban Center Books: The expanse of your library speaks to a breadth of intellectual curiosity, a period of prodigious reading, and perhaps a grand tour. Did you take any architectural pilgrimages in your youth, and do you find yourself in a cultural exchange with the wide range of places you work in today?

Henry N. Cobb: In the summer of 1935, at age nine, I was taken with my brothers on a sort of mini–grand tour (Italy, Switzerland, France), which aroused enthusiasms that later led to my decision to become an architect. In 1947 I spent six weeks studying postwar reconstruction in England, Czechoslovakia, and Poland. And in 1957 I enjoyed a four-month sabbatical in Italy with my wife and our first child. Virtually all my subsequent travel, extensive and far-flung, has mirrored the geographic diversity of my practice. Inasmuch as I believe that works of architecture should always reflect a concern for the specific physical and cultural contexts in which they occur, the investigation of other cultures has of necessity been a constant in my professional life.

Your books appear to have been collected over a long period of time, and the textures and colors suggest that a large number of them may now be collector's items. What is the relationship between your collecting and your development as an architect and thinker? And what informed the particular design of your library?

Most of our great local bookstores have disappeared over the past half century: George Wittenborn, Lucien Goldschmidt, Gotham Book Mart, Books & Co., Madison Avenue Books, to name a few. My wife and I do not regard ourselves as collectors, and only a few of the books in our shared library could be called rare. Every book we own is a book that we want to read, although some remain as yet unread. In my architecture library, on the other hand, perhaps half the books are there for occasional reference rather than for reading. Both libraries reflect in their design my preference for embedded (as opposed to projecting) bookcases, ordered by broad vertical partitions and narrow shelves. Books seem to me most at home in that setting.

Many of your books are exceptional for the qualities of their drawings. Is drawing important to you for resolving ideas in your practice? And what do the drawing skills of young architects say about the nature of design as it is practiced today?

Drawing is always important, even for those like me who are not skilled draftsmen. Ideas emerge through drawing, ideas are tested through drawing, and ideas are represented through drawing. The least important function of drawing is to show others "what it will look like." In this digital era, young architects command new means and methods of representation that are beyond my reach. I do not begrudge them this advantage, provided they take care to place those means and methods in the service of ideas.

LEVINE

THE ARCHITECTURE OF Frank Lloyd Wright

Raymond M. Wood

Center

ELLIS

FRANK LLOYD WRIGHT

HOFFMANN

GENIUS AND THE MOBOCRACY

PRINCETON

FRANK LLOYD WRIGHT'S ROBIE HOUSE

DOVER 0-486-24582-2

BYARD

The Architecture of Additions

BUILDING ON THE PAST

NORTON

van Rensselaer

LIVING ARCHITECTURE

O'GORMAN ROBINSON

H.H. Richardson Chicago

Henry Hobson Richardson and His Works

James F. O'Gorman

Dover 486-22320-A

H. H. Richardson Complete Architectural Works

O'Gorman

Kaufmann

THE RISE OF AN AMERICAN ARCHITECTURE

H. H. RICHARDSON SELECTED DRAWINGS

PRAEGER P-340

GREENE & GREENE

Makinson

1

Makinson

THE CHICAGO SCHOOL OF ARCHITECTURE

CONDIT

THE UNIVERSITY OF CHICAGO PRESS

The Rise of the Skyscraper

The Architecture of Frank Furness

Philadelphia Museum of Art

R

The Architecture of Kallmann McKinnell & Wood

Building the New Museum

Nathan Silver, Editor

Harvard University Graduate School of Design

KARP

THE CENTER

The Architectural League of New York

AMERICAN ARCHITECTURE

THE SKYSCRAPER

KRINSKY

ROCKEFELLER CENTER

GOLDBERGER

OXFORD GB 544

KNOPF

NEW DIRECTIONS IN AMERICAN ARCHITECTURE

The Tall Building Artistically Reconsidered

Ada Louise Huxtable

Pantheon

George Braziller

SZARKOWSKI

THE IDEA OF LOUIS SULLIVAN

Frank Furness The Complete Works

Thomas • Cohen • Lewis • Venturi

Princeton Architectural Press

FILE UNDER ARCHITECTURE

Muschamp

APPLIANCE HOUSE

BEN NICHOLSON

Biographical and Urban Experiments of Italy

BISHOP RICARDO AND JORGE SILVETTI

Harvard University Graduate School of Design

AMERICAN ARCHITECTURE INNOVATION AND TRADITION

R

GRAND CENTRAL TERMINAL City within the City

Deborah Nevins, General Editor

Introduction by Jacqueline Kennedy Onassis

The Municipal Art Society of New York

3

MAN
TALES

W. G. SEBALD · ON THE NATURAL HISTORY OF DESTRUCTION

W. G. SEBALD · AUSTERLITZ

Ve rt i g o · W. G. SEBALD

ECO · THE NAME OF THE ROSE

UMBERTO ECO · THE NAME OF THE ROSE

UMBERTO ECO

THE NAME OF THE ROSE

FOUCAULT'S PENDULUM

Harcourt Brace Jovanovich

NUMBERS IN THE DARK AND OTHER STORIES · CALVINO

DIFFICULT LOVES · ITALO CALVINO

ITALO CALVINO · If on a winter's night a traveler

Thomas Bernhard · On the Mountain

THE LOSER · THOMAS BERNHARD

CORRECTION · THOMAS BERNHARD

NOOTEBOOM · The Following Story

GABRIEL GARCÍA MÁRQUEZ · THE AUTUMN OF THE PATRIARCH · Harper & Row

García Márquez · One Hundred Years of Solitude

CHRONICLE OF A DEATH FORETOLD · GABRIEL GARCÍA MÁRQUEZ

INNOCENT ERÉNDIRA · GABRIEL GARCÍA MÁRQUEZ

In Evil Hour · GABRIEL GARCÍA MÁRQUEZ

Jorge Luis BORGES · COLLECTED FICTIONS · DUTTON

BORGES · THE BOOK OF SAND

JORGE LUIS BORGES · THE BOOK OF IMAGINARY BEINGS

Jorge Luis Borges · Seven Nights · NEW DIRECTIONS

LAMPEDUSA · THE SIREN · HARVILL

PENELOPE FITZGERALD The Means of Escape Houghton Mifflin

THE
FLIGHT
OF THE
MIND

—☆—

THE
LETTERS
OF
VIRGINIA
WOOLF

Volume 1
1888–1912

THE
HOGARTH
PRESS

THE
QUESTION
OF THINGS
HAPPENING

—☆—

THE
LETTERS
OF
VIRGINIA
WOOLF

Volume 2
1912–1922

THE
HOGARTH
PRESS

A
CHANGE OF
PERSPEC-
TIVE

—☆—

THE
LETTERS
OF
VIRGINIA
WOOLF

Volume 3
1923–1928

THE
HOGARTH
PRESS

A
REFLECTION
OF
THE OTHER
PERSON

—☆—

THE
LETTERS
OF
VIRGINIA
WOOLF

Volume 4
1929–1931

THE
HOGARTH
PRESS

THE
SICKLE
SIDE OF
THE
MOON

—☆—

THE
LETTERS
OF
VIRGINIA
WOOLF

Volume 5
1932–1935

THE
HOGARTH
PRESS

LEAVE THE
LETTERS
TILL WE'RE
DEAD

—☆—

THE
LETTERS
OF
VIRGINIA
WOOLF

Volume 6
1936–1941

THE
HOGARTH
PRESS

THE
DIARY
OF
VIRGINIA
WOOLF

★

VOLUME
1915–1919

Introduced by
QUENTIN
BELL

Edited by
ANNE
OLIVIER
BELL

THE
HOGARTH
PRESS

THE
DIARY
OF
VIRGINIA
WOOLF

★★

VOLUME II
1920–1924

Edited by
ANNE
OLIVIER
BELL

assisted by
ANDREW
McNEILLIE

THE
HOGARTH
PRESS

THE
DIARY
OF
VIRGINIA
WOOLF

★★★

VOLUME III
1925–1930

Edited by
ANNE
OLIVIER
BELL

assisted by
ANDREW
McNEILLIE

THE
HOGARTH
PRESS

THE
DIARY
OF
VIRGINIA
WOOLF

★★★★

VOLUME IV
1931–1935

Edited by
ANNE
OLIVIER
BELL

assisted by
ANDREW
McNEILLIE

THE
HOGARTH
PRESS

THE
DIARY
OF
VIRGINIA
WOOLF

★★★★★

VOLUME V
1936–1941

Edited by
ANNE
OLIVIER
BELL

assisted by
ANDREW
McNEILLIE

THE
HOGARTH
PRESS

NIGHT
AND DAY

VIRGINIA
WOOLF

MRS
DALLO-
WAY

VIRGINIA
WOOLF

TO THE
LIGHT-
HOUSE

VIRGINIA
WOOLF

ORLANDO
A Biography

VIRGINIA
WOOLF

Virginia
Woolf's
READING
NOTEBOOKS

CO
R

Top Ten Books
Henry N. Cobb

Isaiah Berlin
*The Crooked Timber
of Humanity:
Chapters in the
History of Ideas*

Joseph Connors
*Borromini and the
Roman Oratory:
Style and Society*

Le Corbusier
Une petite maison

Ross Feld
*Guston in Time:
Remembering
Philip Guston*

R. D. Martienssen
*The Idea of
Space in Greek
Architecture*

Marcel Proust
*Du côté de
chez Swann*
[Swann's Way]

John Summerson
Georgian London

D'Arcy Wentworth
Thompson
On Growth and Form

Paul Valéry
*Degas, Manet,
Morisot*

Robert Venturi
*Complexity and
Contradiction
in Architecture*

ISAIAH BERLIN

THE CROOKED TIMBER OF HUMANITY

CHAPTERS IN THE HISTORY OF IDEAS

BORROMINI
and the Roman Oratory

Style and Society

Joseph Connors

UNE PETITE MAISON

LE CORBUSIER

GUSTON IN TIME

REMEMBERING
PHILIP GUSTON

ROSS FELD

MARCEL PROUST

JOHN SUMMERSON

GEORGIAN LONDON

ARCHITECTURAL STUDY

Revised and Enlarged Edition

ON
GROWTH
AND
FORM

BY

Sir D'ARCY WENTWORTH THOMPSON

CAMBRIDGE UNIVERSITY PRESS

PRINTED IN USA

The Collected Works in English 12

Paul Valéry Degas
Manet
Morisot

Bollingen Series XLV Pantheon

1 The Museum of Modern Art Papers on Architecture

Published by The Museum of Modern Art, New York in association with
The Graham Foundation for Advanced Studies in the Fine Arts, Chicago

Complexity and
Contradiction
in Architecture

Robert Venturi

Liz Diller and Ric Scofidio

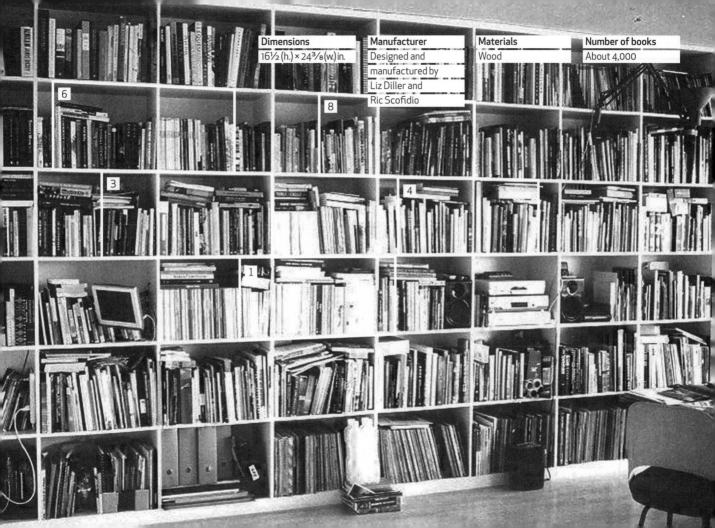

Dimensions
16½ (h.) × 24⅜ (w.) in.

Manufacturer
Designed and
manufactured by
Liz Diller and
Ric Scofidio

Materials
Wood

Number of books
About 4,000

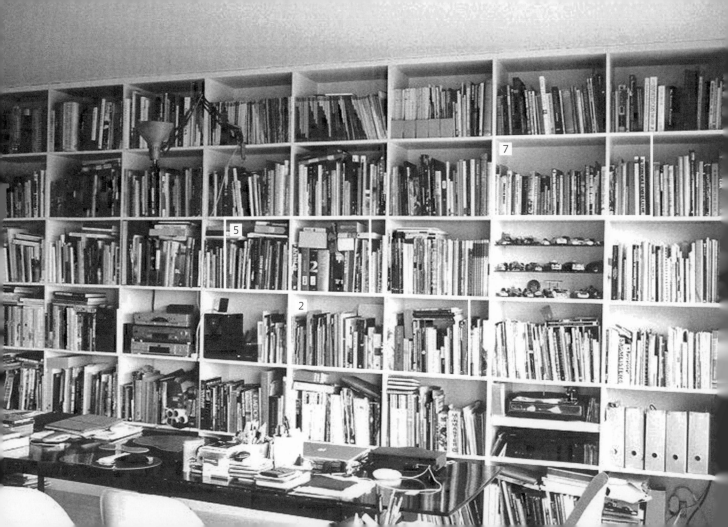

Urban Center Books: Starting in 1981, Diller + Scofidio (the firm) began a series of provocations that might be said to be more art installation than architecture proper. Yet perhaps both these things are the same after all. Can we press the matter of technology, given that your shelves are heavy with technocultural and media titles? Where did this fascination come from?

Diller + Scofidio: Architecture is a technology. If you mean digital, we've often said that architecture's smallest units are bricks and pixels. But technology is only a means to an end, a tool to enhance space-making. Software and hardware must be absorbed, not fetishized.

How did you get from the Cooper Union of John Hejduk, which might be termed technophobic, to the late-1980s Princeton where you embraced phobia, gender, the posthuman, fashion, techno-hubris, and all manner of what we might call celebratory mutations? Do we blame it on Duchamp and Foucault?

Only approved forms of contagion were allowed to see the light of day at Cooper. Yet our interests have always been pancultural. The influence of Cooper was but one trajectory, joined by experimental dance and theater, pop culture, weird science, food, and cultural theory. We may have preferred to respond to your request for our ten favorite books with a list of our ten favorite movies, ten architectural moments, ten composers, ten television shows, ten industrial objects, ten meals, ten vacations, ten distractions, ten dream dinner guests, and ten strong phobias. Or less indexically, ten favorite things: *The Shining,* the Statue of Liberty, Igor Stravinsky, Gary Shandling, a 1930s Bugatti engine, Per Se's "oysters and pearls" dish, Manhattan in August, the *Huffington Post,* Nathan Myhrvold, and fear of dust. Duchamp provoked early thinking about the interplay of pictoral and textual languages. Foucault taught us to see the present through a "thick perception."

Perhaps your Blur Building of 2002 and Eyebeam Museum of Art and Technology of 2004 lead, not chronologically but parasitically, to the Institute of Contemporary Art of 2006. Are your projects influenced by your highly discursive reading, by an omnivorous habit of appropriation and expropriation? And if so, given the place of Walter Benjamin's *The Work of Art in the Age of Mechanical Reproduction* on your top ten list, would you say that you also appropriate your own work?

No. There are themes in our work that are explored differently according to a project's opportunities and limitations. These themes include conventions of space, tourism, mediation, domesticity, changing definitions of privacy, and representation. Blur, Eyebeam, and ICA have in common an interest in visuality—the culture of vision. In Blur, we problematize vision by eradicating depth perception and orientation, thus impeding our reliance on vision as the master sense. Eyebeam constructs controllable visual interfaces between the public and private populations of a new institution. ICA negotiates between the outwardly focused touristic site of the Boston Harbor and the inwardly focused cultural program of the museum. The building is an optical

valve that distributes the view in small doses and turns it on and off.

Benjamin's text spawned a series of experiments that attempted to demolish dualisms such as authenticity and mediation—as, for example, in the Slow House and Moving Target.

A naïve question, if you will. Is not a mediated architecture also an architecture of endless, perhaps overwhelming displacement and illusion? Should we not see Cervantes on your top ten list?

Built work is only one manifestation of an idea. The spoken word is another. The written word, another. The drawing, still another. Our books are on bookshelves, not piling up with other stimuli on the floor to make way for the vacuum cleaner. I'm sure Cervantes is somewhere underneath issues of *Seed,* travel guides, *People* magazine, and a cookbook.

Book spines on a shelf, left to right:

- INNES IRELAND — All Arms and Elbows — PELHAM BOOKS
- AMERICAN ON WHEELS — Men Ideas of Power and Sex, Drink & Fast Cars — Wallis — MORROW
- Wheel Estate — Wallis
- THE CAR CULTURE — Flink — OXFORD
- ROADSIDE AMERICA — The Automobile in Design and Culture — Jennings
- The Auto Album — Tobin
- MAN AND MOTOR CARS — BLACK
- The Automobile Age — Flink
- FLY WHEEL
- AUTOMOBILE
- Small Cars Postcard Book — TASCHEN
- Jackie Stewart's Principles of Performance Driving — OSPREY
- GENERAL MOTORS THE FIRST 75 YEARS
- racing drivers manual — By Frank Gardner
- AUTOMOTIVE MECHANICS — Published by HEINER
- AUTOMOBILE
- CLASSIC CARS IN PROFILE
- THE GRAND PRIX CHAMPIONS
- THE MODERN SPORTS CAR — McCahill — BAY VIEW BOOKS
- A-Z OF CARS 1945-1970 — MICHAEL SEDGWICK — MARK GILLIES
- BEHIND THE WHEEL
- BEHIND THE SCENES WITH BENETTON FORMULA 1 — CHRIS BENNETT
- Great Automobile Designs — John Mclellan
- Robson — The Monte Carlo Rally
- THE COMPLETE AUTOMOBILE
- Classic Cars — Roger Hicks
- JAGUAR Since 1945
- THE NEW GUIDE TO CLASSIC CARS
- AUTOMOBILE AND CULTURE — Martin Roberts — ABRAMS
- Sports Cars

7

Top Ten Books
Liz Diller and
Ric Scofidio

Edwin Abbott
*Flatland: A Romance
of Many Dimensions*

Walter Benjamin
*Das Kunstwerk
im Zeitalter seiner
technischen
Reproduzierbarkeit*
[The Work
of Art in the Age of
Mechanical
Reproduction]

Adolfo Bioy Cesares
*La invención
de Morel*
[The Invention
of Morel]

Michel Foucault
*Les motes et les
choses: Une archéol-
ogie des sciences
humaines*
[The Order of Things:
An Archaeology of
the Human Sciences]

Victor Hugo
L'homme qui rit
[The Man Who
Laughs]

Michael Pollan
*The Omnivore's
Dilemma:
A Natural History
of Four Meals*

Thomas Pynchon
Gravity's Rainbow

Peter Mark Roget
Roget's Thesaurus

Neal Stephenson
Snow Crash

Robert Venturi
*Complexity and
Contradiction
in Architecture*

FLATLAND
A Romance of Many Dimensions
Edwin A. Abbott

THE INVENTION OF MOREL
ADOLFO BIOY CASARES

MICHEL FOUCAULT

The ORDER of THINGS
An Archaeology of the HUMAN SCIENCES

THE MAN WHO LAUGHS
VICTOR HUGO

The Omnivore's Dilemma
A NATURAL HISTORY OF FOUR MEALS
MICHAEL POLLAN

GRAVITY'S RAINBOW
THOMAS PYNCHON

Roget's Thesaurus of English Words and Phrases
Peter Mark Roget

NEAL STEPHENSON
SNOW CRASH

COMPLEXITY AND CONTRADICTION IN ARCHITECTURE
ROBERT VENTURI

Peter
Eisenman

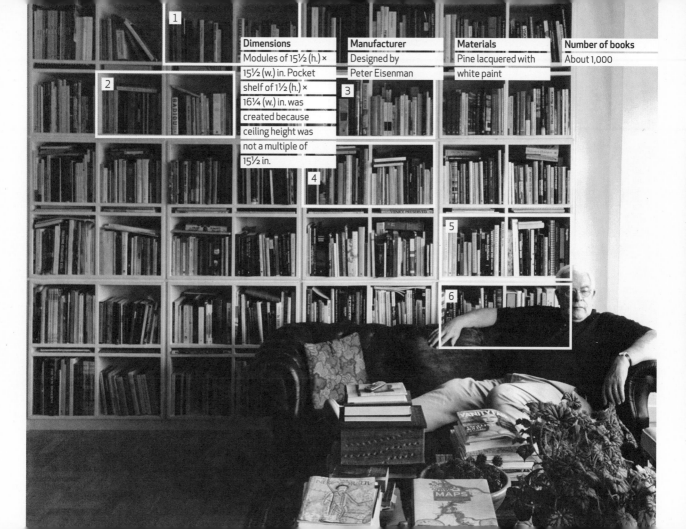

Dimensions	Manufacturer	Materials	Number of books
Modules of 15½ (h.) × 15½ (w.) in. Pocket shelf of 1½ (h.) × 16¼ (w.) in. was created because ceiling height was not a multiple of 15½ in.	Designed by Peter Eisenman	Pine lacquered with white paint	About 1,000

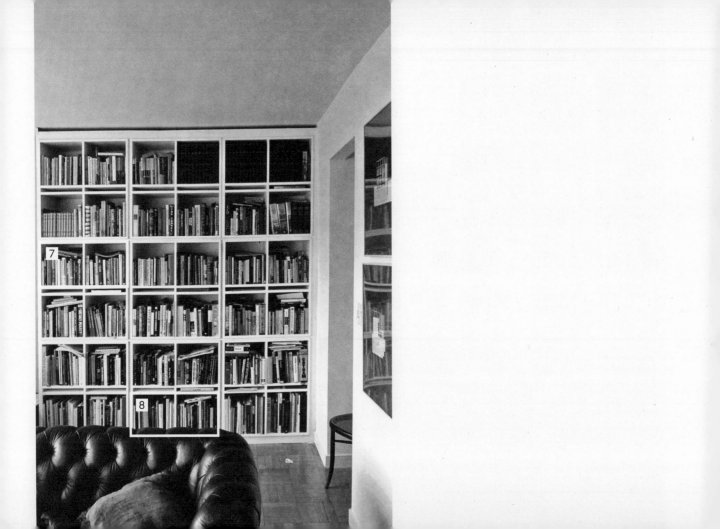

Urban Center Books: Given the wide range of books in your library and on your top ten list, can you say that architecture requires a promiscuous appetite for literature, philosophy, and all kind of works beyond strictly architectural ones?

Peter Eisenman: My main focus is literature, philosophy, and film. I do not believe you can do architecture and not have ideas that come out of culture, in some way. So my idea of reading is like someone going to concerts. My friend Kurt Forster goes to concerts all the time; Jeff Kipnis and Leon Krier play the piano two hours a day. Everybody has some other discourse that informs their ideas about architecture. But it's not being promiscuous; it's part of the "being" of these people.

You have a formidable book collection. Can you tell us a bit about the history of acquiring it, and what the act of collecting means to you?

There are two different aspects to my library. One is a collector's library that reflects my interest in the twentieth century and in modernism, in particular

little magazines. For me, these are the primary sources of my understanding about what was going on at any particular time. These books are not here. They now reside in the Beinecke Rare Book and Manuscript Library at Yale. It is a collection of mine that is quite extensive—perhaps four to five thousand items. I became obsessed with collecting these items, these objects, after my first trip to Europe with Colin Rowe. This was in the summer of 1961, when I was teaching at Cambridge and doing my PhD dissertation. I became obsessed with collecting magazines until 1974, when I could no longer afford to collect. I was starting to send my children to school, paying tuition, etcetera. So my collection basically happened between 1961 and 1974.

My interest in reading began earlier. It was a forced exile that caused it. At Cornell I never read anything. I graduated in 1955. I was in Korea, on the front line, albeit in the armistice line, living in a tent for two years, with nothing to do. I was totally bored. My brother was at Cornell. It was the first year of the Vintage paperbacks. There were Alain-Fournier, Albert Camus, Jean-Paul Sartre, and André Gide, which my brother kept sending to me as they came out. I had the collection from one to thirty or whatever. And I would just read these books, and it was like the opening of a new world to me. I completely changed because I had two years to do nothing but read. There were no films, there was no art, and there was no culture: nothing. So that's when I began to read, and that continued through my years at Cambridge, my years in teaching.

Without *The Four Books on Architecture* of Palladio no one would have cared about Palladio. A book lasts longer than a building; books are more important in the world than buildings. Without Venturi's *Complexity and Contradiction in Architecture* there would be no Bob Venturi. Without Rem Koolhaas's *Delirious New York* there would be no Koolhaas. Without Le Corbusier's *Toward an Architecture,* etcetera. That's why I have them on my top ten list. The books that I mentioned in the list made those architects. Without those books, they wouldn't exist for us. So for me, architects live beyond their time through the book.

For a few of the books on your list, you were in very close contact with the authors when they were producing those works. *Delirious New York* was done at the Institute for Architecture and Urban Studies. Derrida's *Of Grammatology* coincides with your turn to deconstruction and your subsequent friendship with Derrida. Is there a connection?

No, my relationship with Jacques Derrida, with Venturi, with Koolhaas, has nothing to do with their being on the list—not at all. I would like to think that these are objective views, as I view what I know. I have never met Thomas Pynchon, although I would love to meet him. He was in my brother's class at Cornell. What would be more difficult for me would be if you said, name ten films that are the most important to you. That would be more difficult. To say this film is more important than that film would be a difficult operation. But to say ten buildings, I have just written a book about ten buildings [*Ten Canonical Buildings: 1950–2000*] that are very important to me. I think that film would be much more difficult because this is where you have to be more of an expert. I can give you ten buildings and I can pick standard books, but to know film the way people who know film know film...Well, I would not be able to make the assessments that I would be required to make. I read enough, so I know I love when people create with the word, turning it into something more than a mere sentence, more than just a simple idea—that it resonates in some way beyond its mere existence as a word. And I believe that's what architecture does. There are ideas, there are functions, there are words, but when you hit something extraordinary, it's like reading a beautiful book.

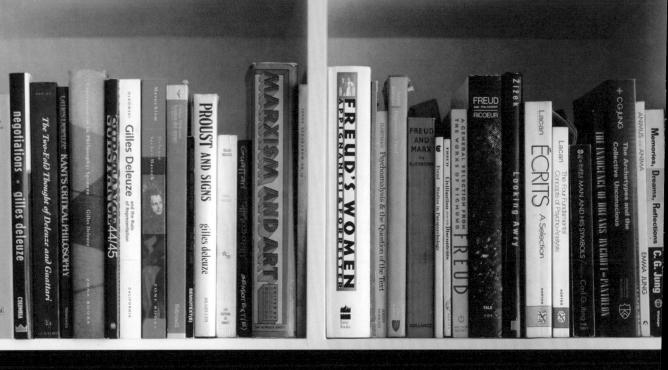

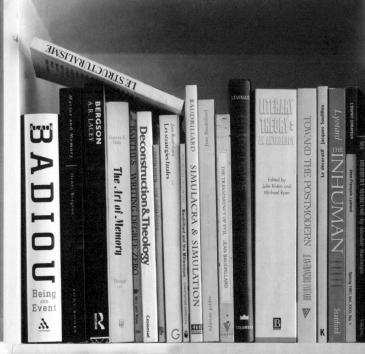

Left shelf (top to bottom, laid flat):

IRENE'S CUNT · Louis Aragon

Shaviro — *Passion and Excess* — Florida State

Standing books (left to right):
- The Accursed Share Volume [I] — SUNY
- BLANCHOT — THE STEP NOT BEYOND — SUNY
- MAURICE BLANCHOT — THE UNAVOWABLE COMMUNITY — Station Hill
- YES — On Bataille — 79
- GEORGES BATAILLE — *The Accursed Share* — ABSENCE OF MYTH — Translated and edited by Michael Richardson — VERSO
- Theory of Religion — Georges Bataille
- Writing and Wisdom
- The Accursed Share Volumes II & III — Georges Bataille — ZONE BOOKS
- THE BATAILLE READER — B
- Bold-Irons
- Literature and Evil — Georges Bataille — VERSO
- MAURICE BLANCHOT — ON BATAILLE — Georges Bataille — SUNY
- Maurice Blanchot
- Maurice Blanchot
- Maurice Blanchot — THE SPACE OF LITERATURE — Which Way to Come
- BLANCHOT — THE LAST MAN — COLUMBIA
- MAURICE BLANCHOT — THE SIRENS' SONG — STATION HILL
- Maurice Blanchot — *The Gaze of Orpheus* — STATION HILL
- FAUX PAS — Blanchot
- Ungar — Maurice Blanchot — Scandal & Aftereffect — Station Hill
- BLANCHOT — AMINADAB — Thomas the Obscure

Right shelf (top to bottom, laid flat):

LE STRUCTURALISME

Standing books (left to right):
- Matter and Memory — Henri Bergson
- BERGSON — A. R. LACEY
- Frances A. Yates — *The Art of Memory* — Chicago
- Deconstruction & Theology — Crossroad
- BARTHES — WRITING DEGREE ZERO — HILL AND WANG
- Jean Baudrillard — Les stratégies fatales
- BAUDRILLARD — Jean Baudrillard — SIMULACRA & SIMULATION — Baudrillard and the Millennium — CHRISTOPHER HORROCKS — G
- THE TRANSPARENCY OF EVIL — JEAN BAUDRILLARD — VERSO
- LEVINAS
- CRITICISM
- LITERARY THEORY: AN ANTHOLOGY — Edited by Julie Rivkin and Michael Ryan — B
- TOWARD THE POSTMODERN — JEAN-FRANÇOIS LYOTARD — COLUMBIA
- Lyotard — THE INHUMAN — Stanford — K
- L'ESPRIT CRÉATEUR — Jean-François Lyotard — Spring 1991, Vol. XXXI, No. 1
- M4 — HERBERT MARCUSE by Alasdair Maclntyre — VIKING

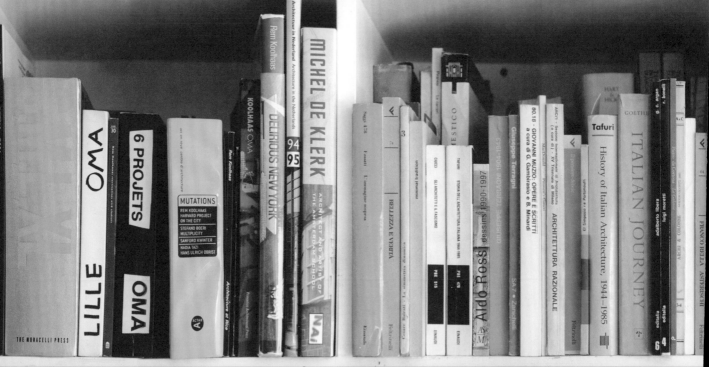

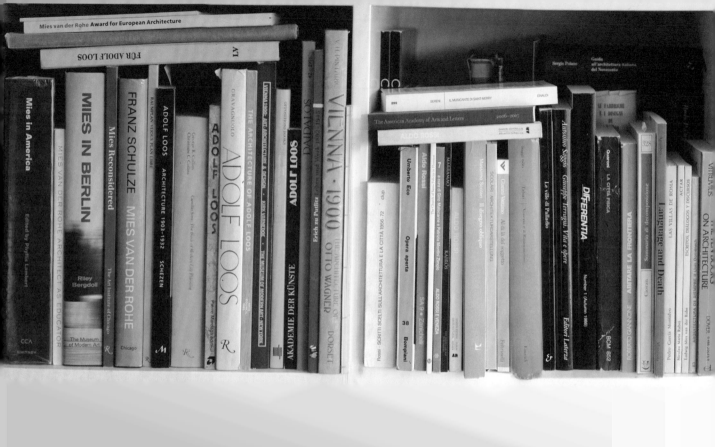

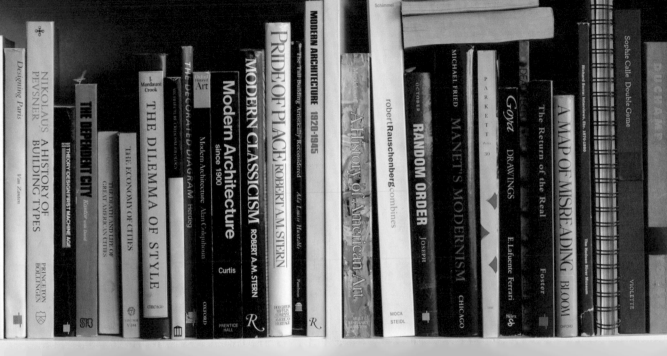

Girouard

CITIES & PEOPLE
A Social & Architectural History

Designing Paris
Van Zanten

NIKOLAUS PEVSNER
A HISTORY OF BUILDING TYPES
PRINCETON BOLLINGEN

THEORY DESIGN FIRST MACHINE AGE
THE DEPENDENT CITY
Kantor van David
ST3

THE DEATH AND LIFE OF GREAT AMERICAN CITIES
THE ECONOMY OF CITIES

I. Mordaunt Crook
THE DILEMMA OF STYLE
CHICAGO

Oxford History of Art
THE DECORATED DIAGRAM Herdeg

ARCHITECTURE IN THE CRISIS OF MODERN SCIENCE

Modern Architecture Alan Colquhoun
OXFORD

Modern Architecture since 1900
Curtis
PRENTICE HALL

MODERN CLASSICISM
ROBERT A.M. STERN
R

PRIDE OF PLACE ROBERT A.M. STERN
HOUGHTON MIFFLIN COMPANY AMERICAN HERITAGE
R

MODERN ARCHITECTURE 1920–1945
The Tall Building Artistically Reconsidered
Ada Louise Huxtable
Pantheon

Schimmel

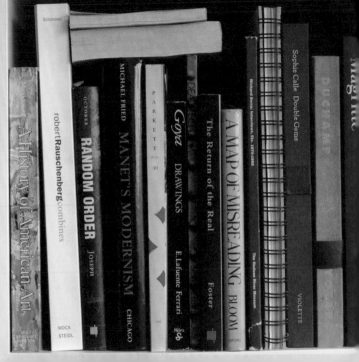

A History of American Art
ABBEVILLE PRESS PUBLISHERS PRINCETON

robert **Rauschenberg** combines
MOCA STEIDL

OCTOBER
RANDOM ORDER
JOSEPH

MICHAEL FRIED
MANET'S MODERNISM
CHICAGO

P A R K E T T
Parkett 30

Goya DRAWINGS
E.Lafuente Ferrari
Silex

The Return of the Real
Foster

A MAP OF MISREADING BLOOM
OXFORD

Richard Serra: Interviews, Etc., 1970-1980
The Hudson River Museum

Sophie Calle: Double Game

DUCHAMP

Magritte

VIOLETTE

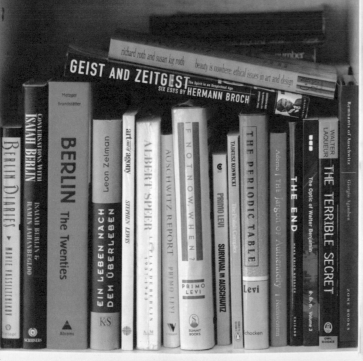
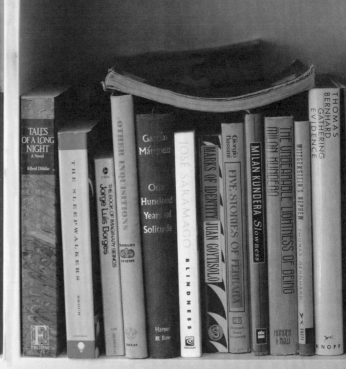

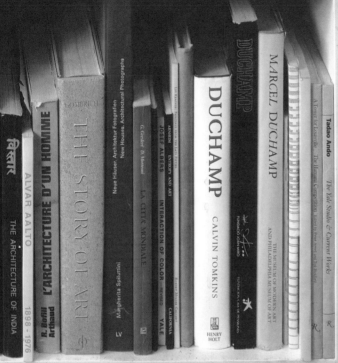
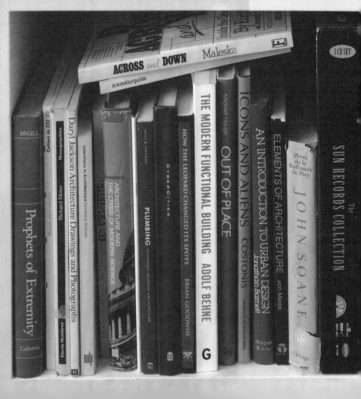

Top Ten Books
Peter Eisenman

Walter Benjamin
Illuminationen
[Illuminations]

Le Corbusier
*Vers une
architecture*
[Toward an
Architecture]

Jacques Derrida
De la grammatologie
[Of Grammatology]

William Faulkner
Light in August

James Joyce
Finnegans Wake

Rem Koolhaas
Delirious New York

Robert Musil
*Der Mann ohne
Eigenschaften*
[The Man without
Qualities]

Andrea Palladio
*I quattro libri
dell'architettura*
[The Four Books
on Architecture]

Thomas Pynchon
Gravity's Rainbow

Robert Venturi
*Complexity and
Contradiction
in Architecture*

ILLUMINATIONS

WALTER
BENJAMIN

Essays and Reflections

Edited and with an Introduction by
HANNAH ARENDT

COLLECTION DE "L'ESPRIT NOUVEAU"

LE CORBUSIER

VERS UNE ARCHITECTURE

LES ÉDITIONS G. CRÈS ET C
PARIS

JACQUES
DERRIDA

OF GRAMMATOLOGY

LIGHT IN AUGUST
WILLIAM FAULKNER
author of SANCTUARY

JAMES JOYCE
Finnegans Wake

Rem Koolhaas

DELIRIOUS NEW YORK

ROBERT
MUSIL
THE MAN
WITHOUT
QUALITIES

GRAVITY'S
RAINBOW
THOMAS PYNCHON

COMPLEXITY
AND
CONTRADICTION
IN ARCHITECTURE
ROBERT VENTURI

Michael
Graves

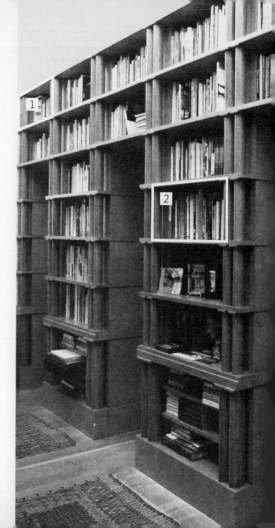

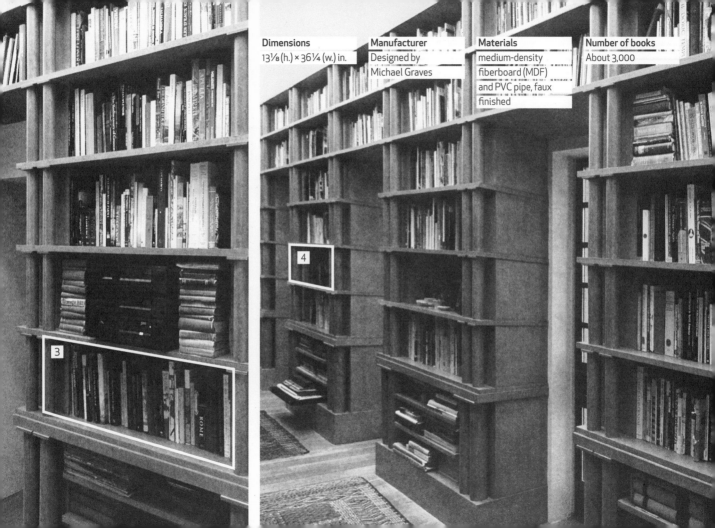

Dimensions
13⅛ (h.) × 36¼ (w.) in.

Manufacturer
Designed by
Michael Graves

Materials
medium-density
fiberboard (MDF)
and PVC pipe, faux
finished

Number of books
About 3,000

3

4

Urban Center Books: Your 1995 show at the Philadelphia Museum of Art, titled "The Architect and the Tea Kettle," embodied a much wider spectrum of interests than is usual for architects. Now we are particularly interested in the role of the book and its status as a designed object, versus simply a text. What is the importance of the book-as-object for you, as collector and author?

Michael Graves: When I started practicing architecture, I didn't know that there was such a thing as a commercial practice—such as some of the big firms in New York pursue. I thought that architectural practices were like that of Le Corbusier—on the one hand an architect and a painter, and on the other a designer of furniture and objects and a maker of books. For Frank Lloyd Wright, the same thing—total design. That is what I thought architects did, and when I began to study history, I knew that architects did do that—when I looked at the lives of the Renaissance architects who were painters, sculptors, and architects.

I started to collect books early on, first books of architecture in high school, and of course

in college. But when Peter Eisenman came to Princeton in 1963, he and I would look at catalogues together. Peter was at that time much more interested in the book as an object than I was. I certainly got the bug from him—that is, an understanding of the role of literature and what it could mean to us in our teaching.

In your list of top ten books we find Robert Venturi's *Complexity and Contradiction in Architecture*, arguably the seminal book for what was later to be called postmodernist architecture. Given that it has become unfashionable over the past two decades to be associated with postmodernism and that even Venturi lately declared that he never was a postmodernist, what role does *Complexity and Contradiction in Architecture* play in your design practice?

I'm sure that many of the people that you're interviewing would recommend as one of their top books Venturi's *Complexity and Contradiction* as well as Le Corbusier's *Toward an Architecture*. Perhaps many people see those works as contradictory.

I also included Colin Rowe's *Mathematics of the Ideal Villa*. In a way Rowe stands between the two, because he reads Le Corbusier for us in a way that makes his work—especially projects like La Tourette—quite metaphorical, almost figurative. What Venturi's book does is return us to an understanding of what a door is, what a window is, and what the human body is, relative to passage through those, either visually or physically. Le Corbusier's emphasis is on the twentieth century and what we can do progressively, whereas Venturi is concerned with the formal language of architecture, as is Colin Rowe—meaning that Le Corbusier was used by some, including Rowe, to give meaning to modern architecture. Le Corbusier did not do that to the extent that Rowe implied he did. Le Corbusier actually said, "We are architects and not engineers because we are humanists." I am an architect because I am a humanist.

There was a duality in medieval philosophy between the "active life" and the "contemplative life," where one way of engaging with the world was to change it actively and

another was to stand back and consider it from a distance. Is that image a good analogy for the roles of the architect and of the writer (or writing architect)?

I probably would not divide the making of architecture into two: designing buildings and writing about buildings. Certainly you can write in a way or build in a way that cancels the other out. You can write in a way and not build, and implore other people to follow that way, and you can do the opposite: you can build and say, "By my buildings you understand my philosophical position."

One of the books you have on your list is *Recueil et parallèle des édifices en tout genre, anciens et modernes*, by J. N. L. Durand, who, not incidentally, was a very influential teacher as well as a writer. You have been teaching at Princeton for almost forty years. Do you see any change in the role of the text given the omnipresent computer?

I can speak only for my own interest. In this regard, I do not so much think about what young architects are interested in. I have colleagues, especially some on the West Coast, who like looking at modern drawings to get their inspiration. I look at modern paintings, but I don't stop there. I want to know where we've come from. And I see students now being excited by the way they can make an object turn in space, inside out and upside down, using the machine. That in itself has become the moment of discovery. But it doesn't engage human concerns, or the myths and rituals of the origins of architecture. I don't see the interest in books and literature, not necessarily books, but the literature of architecture, as I once did.

William Empson Seven Types of Ambiguity

Eliade THE SACRED & THE PROFANE
Myths, Rites, Symbols: A Mircea Eliade Reader
Beane and Doty, Editors Volume 2 HARPER COLOPHON BOOKS

ELIADE MYTH AND REALITY HARPER TORCHBOOKS

The Force and the Crucible MIRCEA ELIADE HARPER TORCHBOOKS

THE NEW ART GREGORY BATTCOCK REVISED

Myths, Rites, Symbols: A Mircea Eliade Reader
Beane and Doty, Editors Volume 1 HARPER COLOPHON BOOKS

ELIADE/MYTHS, DREAMS, AND MYSTERIES HARPER

SPIRIT OF PLACE DURRELL

LANDSCAPE INTO ART By Kenneth Clark

cassirer an essay on man

CASSIRER THE LOGIC OF THE HUMANITIES

LANGUAGE AND MYTH
EDMUND NO. 759
SNOW

BLUNT ARTISTIC THEORY IN ITALY 1450-1600

THE SUCCESS & FAILURE OF PICASSO JOHN BERGER PANTHEON

JOHN BERGER WAYS OF SEEING

Barthes ELEMENTS OF SEMIOLOGY
Barthes

BULFINCH'S MYTHOLOGY VIKING

BLACK MODELS AND METAPHORS CORNELL

CIVILISATION KENNETH CLARK

Cox The Classic Point of View

Burnham THE STRUCTURE of ART Braziller

Camille Image on the Edge Harvard

THE MYSTERIES

FRIED ABSORPTION AND THEATRICALITY
PAINTING & BEHOLDER IN THE AGE OF DIDEROT

THE SENSE OF ORDER GOMBRICH Cornell University Press

THE STORY OF ART

E. H. Gombrich Norm & Form

GOMBRICH · ART AND ILLUSION New Light on Old Masters

E. H. Gombrich TRIBUTES

E. H. Gombrich Symbolic Images Phaidon

Man and his symbols Carl G. Jung Doubleday Windfall

E·H·Gombrich The Heritage of Apelles Cornell University Press

PASSAGES

THE NUDE

E. H. GOMBRICH · MEANS AND ENDS · THAMES AND HUDSON

THE BIRTH AND REBIRTH OF PICTORIAL SPACE JOHN WHITE

The Originality of the Avant-Garde and Other Modernist Myths Krauss

FORM AND MEANING ROBERT KLEIN

Santayana The Sense of Beauty

THE TRANSFORMATION OF NATURE IN ART Coomaraswamy

JOHN SHEARMAN · MANNERISM

Heidegger Poetry, Language, Thought HARPER COLOPHON BOOKS

COLLINGWOOD ESSAYS in the PHILOSOPHY of ART

The Theory of the Avant-Garde Poggioli

HEGEL ON ART

ERICH KAHLER THE DISINTEGRATION OF FORM IN THE ARTS

SUMERIAN MYTHOLOGY

Art and Culture Greenberg

Le Corbusier **MODULOR** Harvard

Le Corbusier **MODULOR 2** Harvard

domus domus domus

UNE MAISON - UN PALAIS

LE CORBUSIER

Le Corbusier

Le Corbusier. THE MARSEILLES BLOCK — Robert Furneaux Jordan

LE CORBUSIER AT WORK

LE CORBUSIER

LE CORBUSIER

LE CORBUSIER 1 Early Works

LE CORBUSIER The Athens Charter

JOURNEY TO THE EAST LE CORBUSIER

le corbusier

Le Corbusier, the Noble Savage

LE CORBUSIER/PIERRE JEANNERET

Le Corbusier Nursery Schools Orion Press

CORBU VU PAR

Fifty Works by Le Corbusier

The Le Corbusier Guide

Le Corbusier Early Buildings and Projects 1912–1923 Garland Publishing, Inc and Fondation Le Corbusier

DUNCAN

PRINCETON UNIVERSITY ART MUSEUM
HANDBOOK OF THE COLLECTIONS

ITALY

POTTER

Glazer
FROM A CAUSE TO A STYLE

the private lives of the impressionists · Sue Roe

SCHINKEL

Thomas Jefferson's Travels in Europe, 1784–1789

SCHINKEL "The English Journey"

YALE

ROBERT HUGHES · SHOCK OF THE NEW

KNOPF

Great & Daly · Cr

Creole Houses

Abrams ▲

Elliott TRADITIONAL OIL PAINTING

Aristides CLASSICAL PAINTING ATELIER

TREASURES OF THE DIA
Detroit Institute of Arts

Cuzin, Franchi, Frezzi The Great Masters of European Art
BARNES & NOBLE

Italian, French, English, and Spanish
Drawings and Watercolors The Detroit Institute

No. Painting Landscape Painting

Views on Europe Europe and German Painting in the Nineteenth Century

THE CENTENNIAL DIRECTORY OF
THE AMERICAN ACADEMY IN ROME

CLASSICISM IN COPENHAGEN — GYLDENDAL

BENTLEY
PALMER THE MOST BEAUTIFUL VILLAGES OF TUSCANY

the Sculpture of Henri Matisse · Albert E. Elsen

ABRAMS

HENRI MATISSE · DRAWING WITH SCISSORS: MASTERPIECES FROM THE LATE YEARS · John Elderfield

PRESTEL

the CUT-OUTS of HENRI MATISSE · GEORGE BRAZILLER

alexander calder: the paris years 1926–1933 Joan Simon · Brigitte Leal

WHITNEY

Calder in Connecticut Guérin · CALDER AT HOME

WADSWORTH ATHENEUM

Ian Barker Anthony Caro · Quest for the New Sculpture

LH

Top Ten Books
Michael Graves

Gaston Bachelard
*La poétique
de l'espace*
[The Poetics of
Space]

Le Corbusier
*Vers une
architecture*
[Toward an
Architecture]

Denis Diderot
*Diderot
Encyclopedia:
The Complete
Illustrations,
1762–1777*

J. N. L. Durand
*Recueil et parallèle
des édifices en
tout genre, anciens
et modernes*

E. H. Gombrich
*Meditations on a
Hobby Horse, and
Other Essays on the
Theory of Art*

Paul Letarouilly
*Édifices de Rome
moderne*

Andrea Palladio
*I quattro libri
dell'architettura*
[The Four Books
on Architecture]

Aldo Rossi
*L'architettura
della città*
[The Architecture
of the City]

Colin Rowe
*The Mathematics
of the Ideal Villa
and Other Essays*

Robert Venturi
*Complexity and
Contradiction
in Architecture*

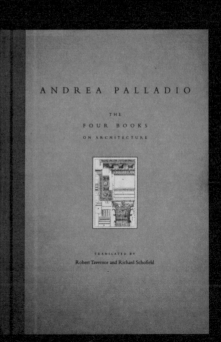

THE POETICS
OF SPACE

THE CLASSIC LOOK AT HOW WE
EXPERIENCE INTIMATE PLACES

GASTON
BACHELARD

WITH A NEW FOREWORD
BY JOHN R. STILGOE

COLLECTION DE "L'ESPRIT NOUVEAU"

LE CORBUSIER

VERS UNE ARCHITECTURE

NOUVELLE ÉDITION REVUE ET AUGMENTÉE

LES ÉDITIONS G. CRÈS ET Cⁱᵉ
PARIS

DIDEROT
ENCYCLOPEDIA
THE COMPLETE
ILLUSTRATIONS

ABRAMS

RECUEIL
ET PARALLÈLE
DES ÉDIFICES DE TOUT GENRE
ANCIENS ET MODERNES

PAR J. N. L. DURAND

E·H·Gombrich
Meditations on
a Hobby Horse
and other essays on the theory of art

Aldo Rossi

The Architecture
of the City

The Mathematics of
the Ideal Villa and Other Essays

Colin Rowe

COMPLEXITY
AND
CONTRADICTION
IN ARCHITECTURE

ROBERT VENTURI

Steven
Holl

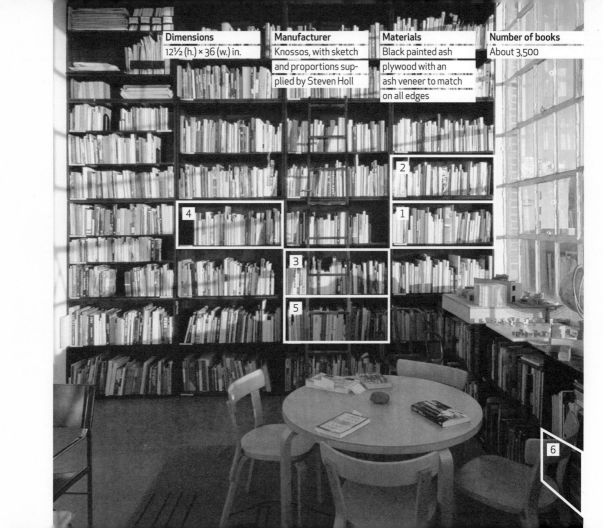

Dimensions
12½ (h.) × 36 (w.) in.

Manufacturer
Knossos, with sketch and proportions supplied by Steven Holl

Materials
Black painted ash plywood with an ash veneer to match on all edges

Number of books
About 3,500

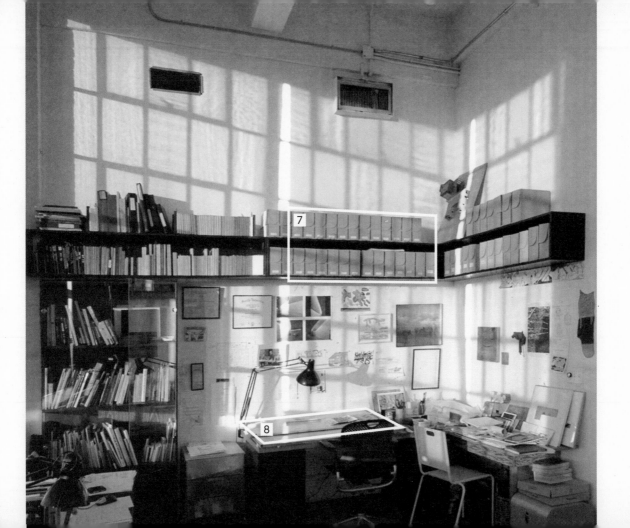

Steven Holl: My obsession with the power of books began while I was an architecture student at the University of Washington in 1967. The library there was not large; however, there were several obscure books, and the idea that you would encounter a book you had never heard or thought of was the most exciting aspect for me.

Later, in 1973, I was the first employee in the bookstore of William Stout in San Francisco. William Stout Architectural Books was open only on Saturdays then. However, it was the beginning of an architectural culture that continues today in San Francisco.

When I came to New York City in 1977 (on an excursion ticket for which I never used the return), I had no books, no library. The library has been built up over years of teaching and, in the beginning, very little practice. Books like *The Mathematics of the Ideal Villa,* by Colin Rowe, were loaned to my students. Many books served as teaching tools in the design studio. Today we have more than three thousand volumes in the office library, which is open to everyone working in our

studio. Often in heated critical discussions over design, we go to the library and get a reference book to supplement the argument. The library is a tool for thought and ongoing discussion, which we constantly use. Besides this library, in the same room I have a library of all the watercolor concept sketches done since 1979, as well as a library of journals I have kept since the mid-1970s. Passions reflected in the imagination can be recalled and explored. If one of the aims of teaching and work is to raise architecture to the level of thought, the library and its books provide a transcendental field with ongoing operative tools.

<u>Urban Center Books:</u> One of the authors on your top ten list is Kafka. Let's start with him, as he seems to be a touchstone of bizarre ideological and denatured forms of being.

Reading Kafka when I first arrived in Manhattan in 1978 gave me a sense of humor to face the absurd. I lived in a cold-water loft with a rent of $250 a month; I showered at the local YMCA and ate at the Four Square Diner. A waitress there approached me when I was reading Kafka. "He was a very strange man indeed," she noted before taking my order. I thought to myself, "Only in New York."

Phenomenology . . . It's a tricky subject with many trap doors, and now post-phenomenology has arrived at the gates of theology. Is there a limit to the appropriation of the phenomenological by architecture? And if yes, does one end up back in metaphysics or theology as a result?

Wittgenstein wrote that there's no such thing as phenomenology. There are only phenomenological questions. In this spirit, there's no limit to questions one may ask in the reading or misreading of phenomenology as a tool to probe experiential dimensions. These questions need not lead back to metaphysics or theology. On the contrary, the probe might be to new dimensions and new connections with science, as in my book *Parallax,* which is an exploration of the overlapping of science and architecture.

Movement, time, phenomenal effects and affects —all these themes are present in your top ten list and in your work, especially your books. Can you say that architecture might one day deliver on this promise of an inherent, vital ethos, generally, versus the creation of private utopias for the elite?

A focus on phenomenological effects of movement in time has been an aim of the creation of public experience in our recent projects. Rather than the creation of private space, we have tried to harness private development forces to shape public space. In the Horizontal Skyscraper now nearing completion in Shenzhen, China, the entire site is a free and open tropical garden. While the hotel, condo, and development offices hover above this new public space, creations of green space and ocean horizon views were part of the reason we won this competition. The core aim is to make private development shape public space.

Given the ability of books to do what is not yet possible, or even to present the impossible, and given your own books and experimental (unbuilt) projects, could you say that the book is in fact capable of more than the world could ever allow? And could this experimental aspect not also be the merit of architecture?

I've felt that a book is like a building, and a building is like a book. Instilling either with intensity is an exciting challenge, which continues in the printed work. I once attempted to make a building out of Julio Cortázar's famous book *Hopscotch*, a book that can be read straight through or according to Cortázar's formula, skipping several chapters, reading it another way with a different meaning. Unfortunately, my attempt failed.

1

PLAY MOUNTAIN · サム・ノグチ + イス・カーン

ISAMU NOGUCHI · A Study of Space

noguchi · Steidl

NONAS SCULPTURE

建築文化

JEAN NOUVEL · ジャン・ヌーヴェル

ANTTI NURMESNIEMI

1983

JOSEPH M. OLBRICH

ART + ARCHITECTURE

olson sundberg kundig allen

DENNIS OPPENHEIM

Ottagono

CHARTA

NAM JUNE PAIK · Video Time—Video Space

NAM JUNE PAIK A VINCI

PERFORMA

Jürgen Partenheimer

I.M. Pei · Zeichnungen Drawings · Richter Verlag

ARTISTS ARCHITECTS

Carlo Pession Architecture 1970 - 2000

ANTOINE PEVSNER

de Architekten Co

Complete works Volume two

Complete works Volume one

Philharmonie

RENZO PIANO - FONDATION BEYELER

Aurora Place Renzo Piano Sydney

PICABIA

RUBIN

Picasso and Braque: Pioneering Cubism

O PIENE MORESKY

ETTLA

PIRANESI AS DESIGNER

JOHN HILTON ELLY

The Mind and Art of Giovanni Battista PIRANESI

Prelovšek

PLEČNIK

JOŽE PLEČNIK 1872–1957

ROBERT POLIDORI'S METROPOLIS

NAIFEH SMITH

Jackson Pollock

GIO PONTI

ARTISTS ARCHITECTS

Robert Bly IRON JOHN

THIS HOUSE OF SKY

Paul Auster The Art of Hunger

SNEAKY PEOPLE THOMAS BERGER

Thomas Berger Conversations

EDGAR HUNTLY BROWN

THE RIDDLE OF THE SANDS

JAZZ, JAIL AND GOD Mel Clay

CORTAZAR BLOW-UP AND OTHER STORIES

THE PHYSICISTS BY FRIEDRICH DÜRRENMATT

THE NAME OF THE ROSE

John Peter

ROBBE-GRILLET Ghosts in the Mirror

PRIEST in contradiction

The Hidden Messages in Water

The Art of War

JÜNGER

JAMES JOYCE — Portrait of the Artist

KIPU

DUBLINERS

KAFKAMERIKA

MILAN KUNDERA

PURPLE DOTS · JIM LEHRER

KAPUT!

BELOVED TONI MORRISON

V.S. NAIPAUL

THE ENIGMA OF ARRIVAL

Animal Farm GEORGE ORWELL

POEMS IN PROSPECT

SPANDAU The Secret Diaries BY ALBERT SPEER

MAPS OF THE IMAGINATION: THE WRITER AS CARTOGRAPHER

RED MAN'S AMERICA

COAST SALISH ESSAYS

Raymond Williams CULTURE & SOCIETY

FERNAND BRAUDEL

COLLAPSE

Men, and Relationships

Tango Nostalgia

John Adams DAVID McCULLOUGH

Top Ten Books
Steven Holl

Paul Celan
Last Poems

Le Corbusier
*L'atelier de la
recherche patiente*
[Creation Is a
Patient Search]

Gilles Deleuze
*Cinéma 1: L'image-
mouvement*
[Cinema 1: The
Movement-Image]
*Cinéma 2:
L'image-temps*
[Cinema 2:
The Time-Image]

Paul Griffiths
*Modern Music:
The Avant-Garde
since 1945*

Knut Hamsun
Sult
[Hunger]

Franz Kafka
*The Diaries of Franz
Kafka, 1910–1913*

Herman Melville
Moby-Dick

Maurice
Merleau-Ponty
*Le visible et
l'invisible, suivi de
notes de travail*
[The Visible
and the Invisible:
Followed by
Working Notes]

Robert Payne, ed.
*The White Pony:
An Anthology of
Chinese Poetry from
the Earliest Times
to the Present Day*

Marc Treib
*Space Calculated
in Seconds:
The Philips Pavilion,
Le Corbusier,
Edgard Varèse*

PAUL
CELAN

A Bilingual Edition
Translated by Katherine Washburn
and Margret Guillemin

LAST
POEMS

CINEMA 1

gilles
DELEUZE

the movement-image

translated by hugh tomlinson and
barbara habberjam

CINEMA 2

gilles
DELEUZE

the time-image

translated by hugh tomlinson and
robert galeta

Paul Griffiths
MODERN MUSIC
the avant garde
since 1945

HUNGER

A NOVEL

KNUT HAMSUN

Diaries
1910-1913

KAFKA

MOBY
DICK

Northwestern
University
Studies in
Phenomenology
and Existential
Philosophy

The Visible and
the Invisible
Maurice
Merleau-Ponty

THE WHITE
PONY

AN ANTHOLOGY OF
CHINESE POETRY

EDITED BY ROBERT PAYNE

Toshiko Mori

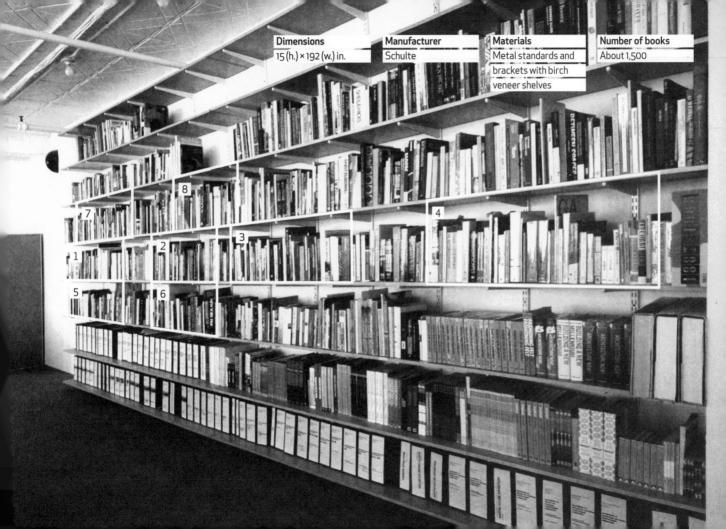

Dimensions
15 (h.) × 192 (w.) in.

Manufacturer
Schulte

Materials
Metal standards and brackets with birch veneer shelves

Number of books
About 1,500

Urban Center Books: Could you begin by talking about how your reading has informed your practice?

Toshiko Mori: I was a student of John Hejduk's at the Cooper Union, and of course for him literature was just as important as architectural history. We didn't really talk much theory or philosophy then, but we read poetry quite a lot, and I think reading books is as much work as drawing. As a child I was a voracious reader; I read all the time and I drew all the time. It was therefore natural for me to be more ambitious and include reading in my architectural studies.

Did Hejduk influence your future reading?

Of course, and that's why I listed two of his books in my list of ten. I am reminded all the time of how he taught me to look at words and drawings as interrelated. He talked about poetics in architecture. He was a romantic thinker, but he talked about architecture and the poetics of architecture in the most matter-of-fact way. It was a very

interesting combination of streetwise pragmatism and philosophy. He was interested in the ethereal effects of architecture. He spoke about atmosphere a lot; he taught us not only about designing buildings but also how to go deeply into the atmosphere of buildings. What will the quality of the space be? How will people respond? How will buildings behave within the urban context? That's why his books have buildings as characters instead of human subjects. It's about the animation of inanimate objects.

Hejduk's famous project Chronotope is an example of all of that. It traveled around the world, if I am not mistaken.

That's exactly right. So in a way he didn't define architecture in books as much as with very different kinds of productions. He even taught that books are architecture in their own right, and he produced books as if they were works of architecture. Reading books is an architectural experience, and I still feel that way. It is an imaginary way of participating in spatial structures.

You own books on technology, literature, fiction, and poetry. Taken together, they seem to convey the mix of influences on your work—the liminal and shadowy world of pure contingency.

I am influenced by how technology changes things—from the handmade to the machine made to digital production—and that is the basis of how I think about making buildings. But at the same time I am interested in the effects of architecture and how it manifests itself beyond objects in terms of sequences of spaces, effects of light and color. Junichiro Tanizaki's *Makioka Sisters* contains an amazing description of houses and spaces and the way people live in and move about them, and how Westernization impacts that lifeworld. But it's also very much rooted in time, as a description of the sisters' different age groups and personalities, and how they are affected by their observations of nature, by new transportation systems, and by the way their traditional way of living is slowly colliding with modernity. This miniaturization of everyday life is beautifully

illustrated and described in books by Tanizaki and Yukio Mishima.

You wrote the foreword to Arata Isozaki's *Japan-ness in Architecture,* and I think that book is a type of corrective because he has been perceived as the quintessential postmodernist architect for so long. The two of you have in a way hybridized that Japanese aesthetic sensibility and the modernist aesthetic. But is not the book *Japan-ness* in a sense a return to origins?

Well, no, I think of *Japan-ness in Architecture* as a compilation of his essential writings—a body of written work that has been behind his architectural work continuously. I think of him as one of the most important intellectuals. The way he writes is closer to the literary than any other architect I've read. Sometimes it is obscure, sometimes ambiguous, but just trying to decode one sentence of his architectural writing is a challenge in itself. It has amazing scholarship, erudition, intelligence. If you really look at his body of work from a literary perspective, you see not just styles of architecture but styles that are manifestations of concepts and different ideas of his time. In *Japan-ness* he talks about going beyond the world of architecture, beyond the world of architects, toward political and cultural issues—toward the much more complex and unresolved issues that architects have had to confront in different eras in Japan.

If you could add one book to your list, what would it be?

It would be Jay Fellows's book *The Failing Distance: The Autobiographical Impulse in John Ruskin.* It's about Ruskin's distrust of Renaissance perspective and how it "fails." Fellows, a literary critic, taught at the Cooper Union, and this theoretical book influenced Hejduk's work. Fellows's work is about relationships between perception and conception. No one has ever described these relationships in quite this way. For me, the schism in world culture—in knowledge—is reducible to

the war between the eye and the brain. He has
in effect written an amazing analysis of aesthetics.
It's a treatise on distance and perspective, about
flatness in painting and drawing, as it affects the
so-called biographical subject.

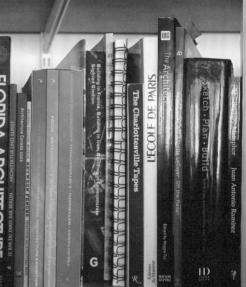

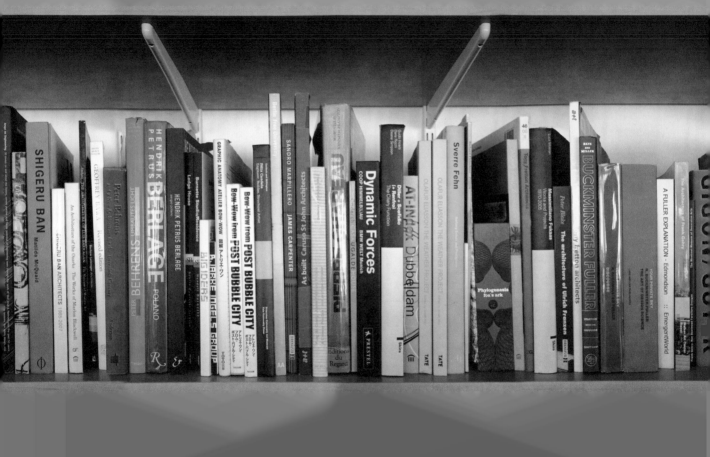

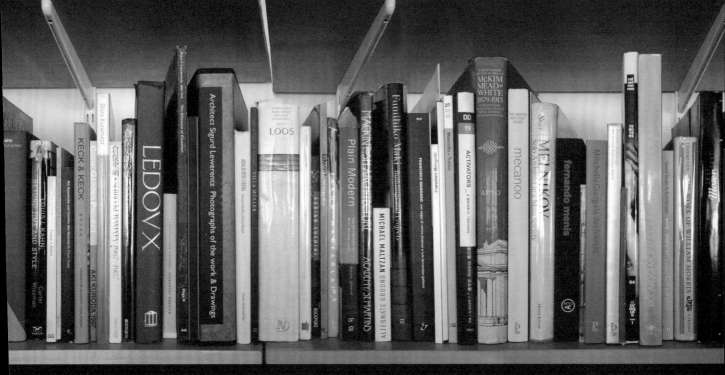

SOUNDINGS

A WORK BY JOHN HEJDUK

RIZZOLI

VICTIMS

a work by John Hejduk

PART 1
Architectural Association
London
1986

A Diderot Pictorial Encyclopedia of
TRADES AND INDUSTRY
485 Plates Selected from 'L'Encyclopédie' of
Denis Diderot

Edited with an Introduction and Notes by
Charles C. Gillispie

In Two Volumes
Volume One

Programs and manifestoes
on 20th-century architecture

Ulrich Conrads

Mechanization
Takes Command
a contribution to anonymous history
By SIEGFRIED GIEDION
author of *Space, Time and Architecture*

A study of the evolution of mechanization
in the last century and a half, its effects on
modern civilization, and its historical and
philosophical background.

Yukio Mishima
The Sea of Fertility

"These four remarkable novels are the most complete
vision we have of Japan in the twentieth century."
—Paul Theroux in *The Times*

Technics
and Civilization
LEWIS MUMFORD

A Harvest/HBJ Book

THE SILENT CRY
A Novel

Kenzaburo Oe

DEVELOPMENT
AS
FREEDOM

AMARTYA SEN

WINNER OF THE NOBEL PRIZE IN ECONOMICS

"Fascinating. . . . The overall argument [is] eloquent and probing."
—*The New York Times*

THE
MAKIOKA SISTERS

JUNICHIRŌ
TANIZAKI

"A masterpiece of great beauty
and quality." —*Chicago Tribune*

Michael
Sorkin

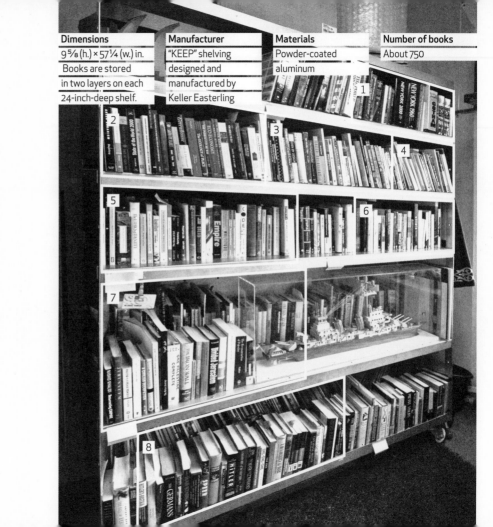

Dimensions
9 5/8 (h.) × 57 1/4 (w.) in. Books are stored in two layers on each 24-inch-deep shelf.

Manufacturer
"KEEP" shelving designed and manufactured by Keller Easterling

Materials
Powder-coated aluminum

Number of books
About 750

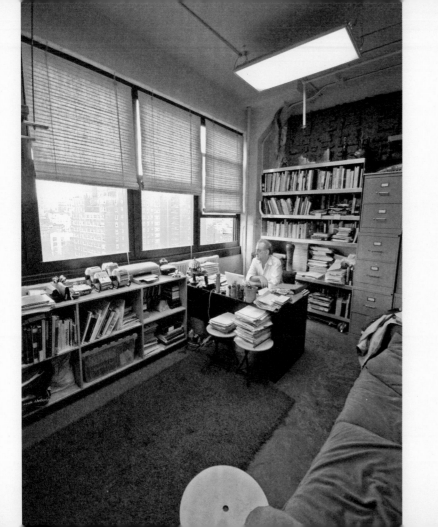

Michael Sorkin: I have just had the melancholy duty of emptying my childhood house of its contents. These included hundreds of books dutifully stored by my late parents, mainly my undergraduate and graduate school accumulation. With no shelf space waiting in New York, ruthlessness was required, but my impetus to chuck was tempered by several factors, beginning with sentimentality. Books have talismanic powers, and that dog-eared Aristotle evoked Richard McKeon's terrifying class questions just as the volume of Apollinaire, whose pages were just short of dust, recalled antics with Iven, next to whom I always sat around the big seminar table. Then there's that vague disquiet about disposing of books, the leap to Nazis and book burnings and *Fahrenheit 451*. I had been guarding a lot of human achievement for quite a few years and wanted to make sure the great chain remained unbroken. I plucked a few beautiful, important, and inscribed volumes from the shelves and gave the rest away.

Both your written and your architectural work are deeply engaged with urban life. In your office, your bookshelves almost perfectly frame an expansive view over parts of Manhattan. Inversely, one may also perceive the view as a perfect addition to the collection of your books. Which takes precedence over which?

Pure symbiosis. One set of texts cannot be fully illuminated without the other.

You have written extensively on design, in turn you have also designed your own monograph as a book-object, and you have formulated design propositions through books like *Local Code,* which seem to suggest architectural intervention through the written word. What role does the written word, and specifically the book, play as a medium for the production of space today?

Space is a social production, the outcome of ideas and relationships. Books are arguments—even propaganda—for the forms, qualities, possibilities, and rights that constitute "space." Books, of course, are not the only way of "writing" space—living in

it is even more primary—but, given the contested character of space today, writing is a crucial mode of both invention and resistance.

The "political" is a hot subject right now—for philosophers, but also for activists and activist-architects. On your shelves we find Giorgio Agamben's *Coming Community* and *The State of Exception.* Those, plus Ernst Bloch's *Spirit of Utopia,* would seem to suggest that the political (as opposed to mere politics) is one of the primary concerns for a progressive architecture. Let's say that the "space of the political" is the issue. Would you agree, and would you comment on the role of these books in your work, inclusive of teaching and writing? One thinks immediately, for example, of your project for East Jerusalem and for a Palestinian Parliament.

Space is intrinsically political. That is, it is a medium for the distribution of power, rights, fantasy, and pleasure. In an age increasingly dominated by issues of shortage, inequality, and the corporate manipulation of desire, space—and the city in particular—is the territory on which the struggle

for good lives and good planetary citizenship must be waged. Those books are not tucked away but right at eye level. I am still someone who believes in the project of utopia, of freely imagining better futures. As those two titles suggest, the shadow of Auschwitz looms over anything that smacks of totalitarianism, and rightly so. But part of my project as both writer and designer is to help free up a space for thinking at every appropriate scale and to look at the spatial component of the political. From the perspective of space, for example, there is no reason why both Israelis and Palestinians cannot declare Jerusalem to be their eternal and undivided capital. That may be an epistemological paradox, but spatially it's a piece of cake.

If we finally got our priorities straight, if we could say we were on the verge of a new political-economic order, what could be the concrete means of integrating those interests represented on your shelves—the political, the environmental and ecological, the urban, and most of all, the social? Is this the task of architecture, after all?

As you may know, I run both a professional office and a nonprofit, activist think tank, Terreform. Our major project at Terreform is the preparation of an alternative master plan for New York City, which we've been calling New York City (Steady) State. The premise is simple: New York can become completely self-sufficient (in water, air, food, energy, manufacture, movement, and so on) within its political boundaries. This is a thought experiment designed to test the limits of architecture and urban organization, to maximize local responsibility, to devise means for inventorying success, to assert the primacy of the city as an increment of democratic politics, and to explore the specific prosody of the physical interventions necessary. And, not to sound too vapidly humanistic, it is part of the biopolitical defense of the body as the center of our fight for freedom, democracy, and happiness.

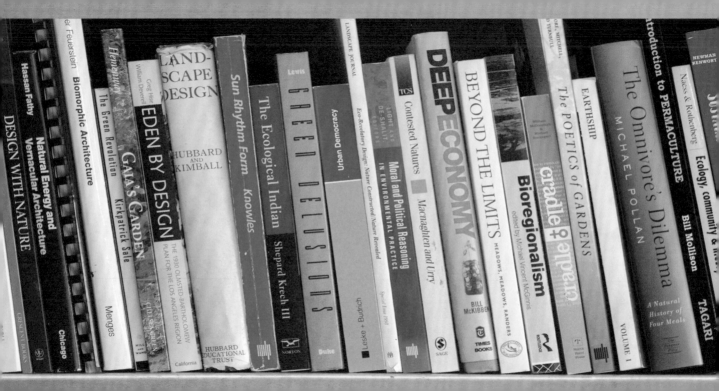

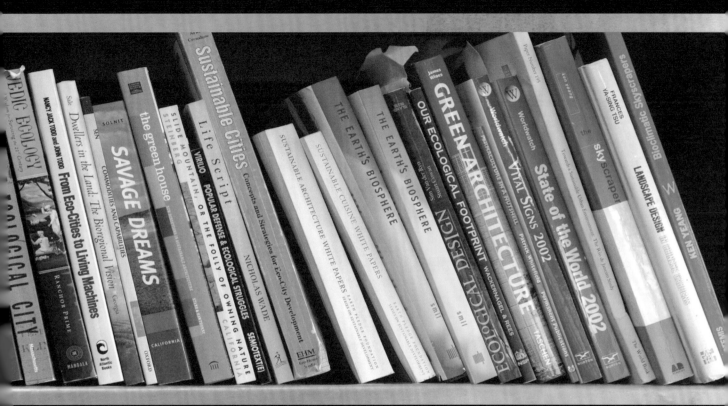

4

6

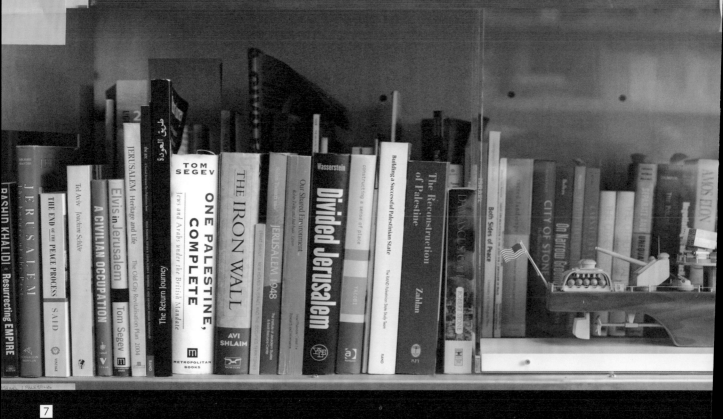

Top Ten Books
Michael Sorkin

The following list
comprises ten of
the twelve books
on Michael Sorkin's
reading list for
incoming students
of urban design.

Marshall Berman
*All That Is Solid
Melts into Air:
The Experience of
Modernity*

Christine Boyer
*Dreaming the
Rational City:
The Myth of
American City
Planning*

Manuel Castells
*The Rise of the
Network Society*

William Cronon
*Nature's Metropolis:
Chicago and
the Great West*

Mike Davis
*City of Quartz:
Excavating
the Future in Los
Angeles*

David Harvey
*Social Justice and
the City*

Michael Hough
*Cities and
Natural Process:
A Basis for
Sustainability*

Jane Jacobs
*The Death and
Life of Great
American Cities*

Henri Lefebvre
La révolution urbaine
[The Urban
Revolution]

Raymond Williams
*The Country and
the City*

ALL THAT
IS SOLID
MELTS
INTO
AIR

THE EXPERIENCE
OF MODERNITY

MARSHALL
BERMAN

Dreaming
the
Rational
City

The Myth of
American
City Planning

M. Christine Boyer

THE INFORMATION AGE:
ECONOMY, SOCIETY AND CULTURE

Volume I

THE RISE OF THE
NETWORK
SOCIETY

Second Edition

NEW
EDITION

Manuel Castells

NATURE'S
METROPOLIS

Chicago and the Great West

WILLIAM CRONON

MIKE DAVIS
WITH PHOTOGRAPHS BY ROBERT MORROW

CITY
OF QUARTZ

Excavating the Future in Los Angeles

Social Justice
and the City

REVISED EDITION

DAVID HARVEY

CITIES
& NATURAL
PROCESS

A BASIS FOR SUSTAINABILITY
MICHAEL HOUGH
SECOND EDITION

JANE
JACOBS

THE
DEATH
AND LIFE
OF GREAT
AMERICAN
CITIES

FOREWORD BY
THE AUTHOR

Henri Lefebvre

The
Urban Revolution

Foreword by Neil Smith
Translated by Robert Bononno

THE
COUNTRY
AND
THE
CITY

RAYMOND WILLIAMS

Bernard
Tschumi

Dimensions
12⅜ (h.) × 28⅛ (w.) in.

Manufacturer
RTI Shelving

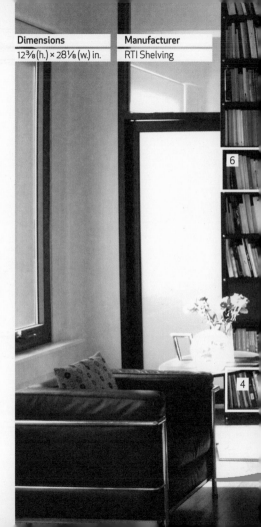

6

4

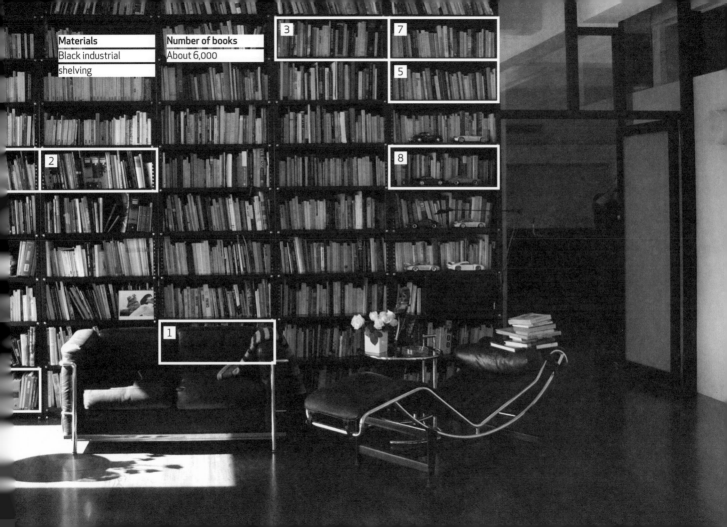

Materials
Black industrial shelving

Number of books
About 6,000

Urban Center Books: Considering *Event Cities*, *Manhattan Transcripts*, and the film books in your top ten list.... Could we start with the idea of visuality and architecture? Are we not entering a charmed circle of architectural representation that is the antithesis of modernism?

Bernard Tschumi: I try to stay away from "visuality" as much as possible. Duchamp's "anti-retinal" stance and emphasis on the conceptual always seemed to me perfectly appropriate to architecture.

One has to wonder about the migration of various arts and disciplines into architecture proper. Is it something we could say preceded and followed modernism's hegemony? Henry Cobb tells the story of having to hide his interest in history while at Harvard in the Gropius years. He even says that Gropius actually tried to purge the library of such things.

Architecture doesn't exist in a vacuum. Architecture is made out of a few constants and many variables. Most of the variables are cultural, technological, social, economic, even philosophical. Hence there

is a lot of importing and exporting between architecture and other disciplines. None of this should be "hidden," and most of it really isn't hidden to the informed observer.

Your top ten list includes works by Georges Bataille, Jorge Luis Borges, and Sergei Eisenstein. Perhaps they point to the filmic and cinematic concepts of your work? Is their presence on the list symptomatic of a type of discourse that permits you to circumvent certain conventions of architectural presentation?

Good question. The cinematic is inextricably related to the architectural. Read again Eisenstein's text "Architecture and Montage," where he explains what he learns about montage while studying the arrangement of temples on the Acropolis in Athens. So my interest is not "extracurricular," as you say, but instead embedded into the very definition of architecture as "space, event, movement."

When did you begin to build your library, and is there a trajectory of interests—a time line—that the library maps?

My library begins with my student years. The books are in French and in English, and sometimes the same book is present in both languages. Many of the art books, as well as the books on literary and cultural criticism, belong to my wife, Kate Linker, the art critic. There is no real boundary established between disciplines. As in real life, there are plenty of crossovers between art, architecture, film, philosophy, literature, and so on.

Karl Lagerfeld claims that he reads ten books at once. How about Bernard Tschumi?

Reading is often a function of having the time. The architectural world of document production and site supervision is very time consuming, so you inevitably read less, or rather you read with a specific goal in mind, rather than as a free-ranging explorer.

You have often told the story of coming to New York from Paris, after London, and being interested at first in art. Do you find that contemporary art and architecture tend to converge, once again, as they did in the late 1960s and early 1970s? If so, it would seem that all of the arguments regarding the autonomy of architecture are in vain.

Autonomy in architecture means different things to different people. For a long time it meant a rather narrow ideological religion. Today I would prefer using the notions of constants and variables. Constants are like genetic material; they change very slowly. Variables are somatic, meaning they show influences, adaptations, and even technological fashions.

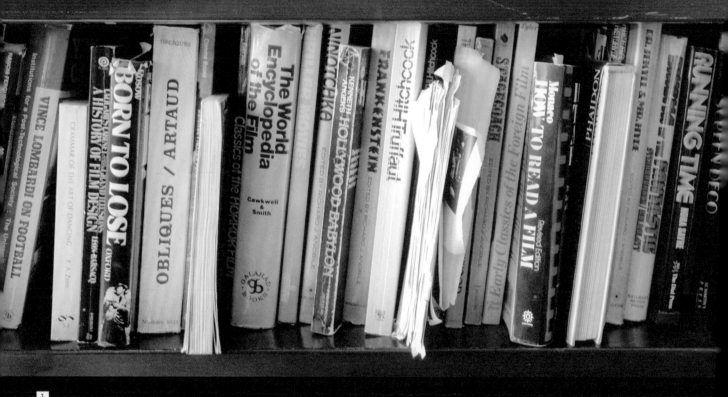

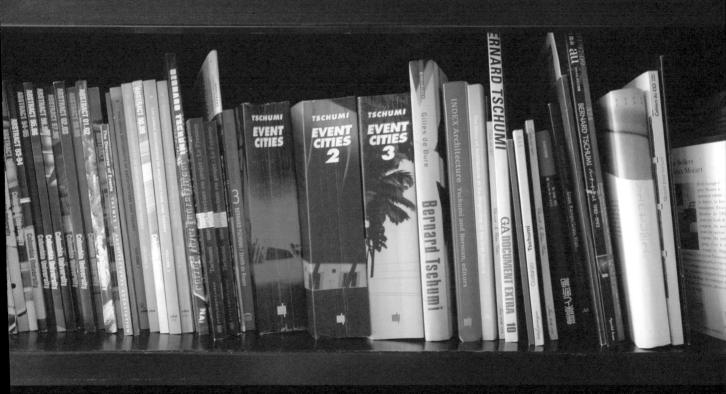

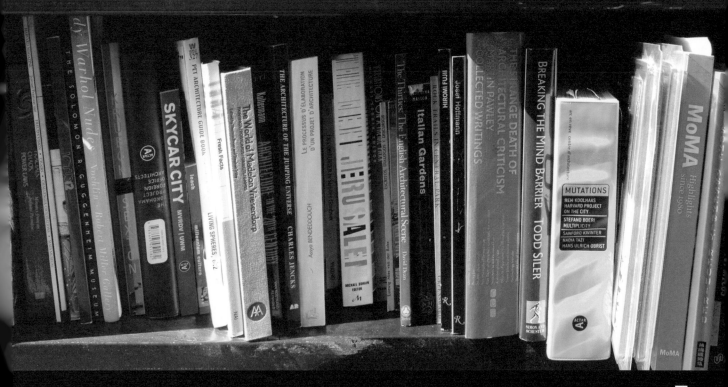

4

5

Existence, Space & Architecture — Norberg-Schulz — RAEGER

DOPO L'ARCHITETTURA MODERNA — Portoghesi

Socialismo, città, architettura URSS 1917-1937 — BCM 838

BILDFÄLLE

COSTANTINO DARDI semplice lineare complesso — 1 — Edizioni Kappa

Architecture and the Crisis of Modern Science — Perez-Gomez

WALTER GROPIUS — the new architecture and the bauhaus — l'architecture de la période stalinienne

Philosophical Investigations — Ludwig Wittgenstein

WITTGENSTEIN TRACTATUS LOGICO-PHILOSOPHICUS — RKP

Roma interrotta

L'Expressionnisme et les arts — JEAN-MICHEL PALMIER — PAYOT

SÉMIOTIQUE DE L'ESPACE

UTOPIES ET RÉALITÉS EN URSS 1917-1934 — 185

URSS 1917-1978

LA VILLE L'ARCHITECTURE

Toward a Rational Society — Habermas

FRASER — Violence in the Arts

PEVSNER — THE SOURCES OF MODERN ARCHITECTURE AND DESIGN — OXFORD

HENRI LEFEBVRE — la production de l'espace

théories et histoire de l'architecture — manfredo tafuri

Architecture and Utopia — Tafuri

Manfredo Tafuri Francesco Dal Co — Architettura Contemporanea/1 — Tafuri

The Sphere and the Labyrinth — Tafuri

anachroniques — Architecture "radicale" — CASABELLA

RATIONAL ARCHITECTURE RATIONNELLE — 1978 — F.-M. de SOM — LA QUESTION DES TEXTES

la scenografia

Daniel Payot

7

GEORGES BATAILLE

HISTOIRE
DE L'EIL

L'IMAGINAIRE

GALLIMARD

LABYRINTHS
Selected Stories & Other Writings
BY JORGE LUIS BORGES

Double Indemnity

James M. Cain

"No one has ever stopped in the middle of one of
Jim Cain's books." — *Saturday Review of Literature*

Le Corbusier

Les Éditions d'Architecture

The
Film
Sense
Serge
Eisenstein

FABER paper covered EDITIONS

**THE
HAUNTED SCREEN**
LOTTE H
EISNER

Bibliothèque
des
HISTOIRES

Surveiller
et punir

Naissance de la prison
par
MICHEL FOUCAULT

nrf

Editions Gallimard

Jacques Gubler

Jean Tschumi
Architecture at Full Scale

SKIRA

JAMES JOYCE
Finnegans Wake

Philippe Sollers
L'écriture
et l'expérience
des limites

Sade Dante
Lautréamont
Mallarmé Artaud
Bataille

points

Tod Williams and Billie Tsien

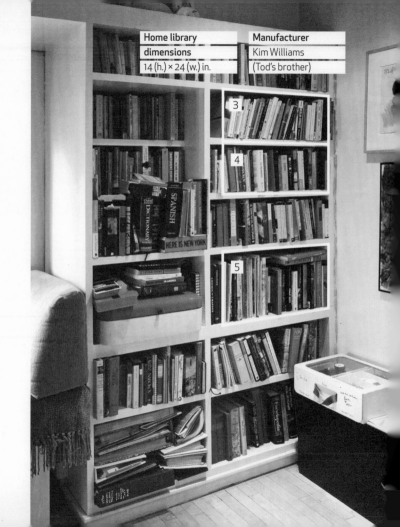

Home library dimensions	Manufacturer
14 (h.) × 24 (w.) in.	Kim Williams (Tod's brother)

Materials
Plywood with hardwood edges, screws, and white enamel

Number of books
About 950

Office library dimensions
13¾ (h.) × 19⅛ (w.) in.

Manufacturer
Stephen Moses

Materials
Plywood with hardwood edges, screws, and white enamel

Number of books
About 1,875

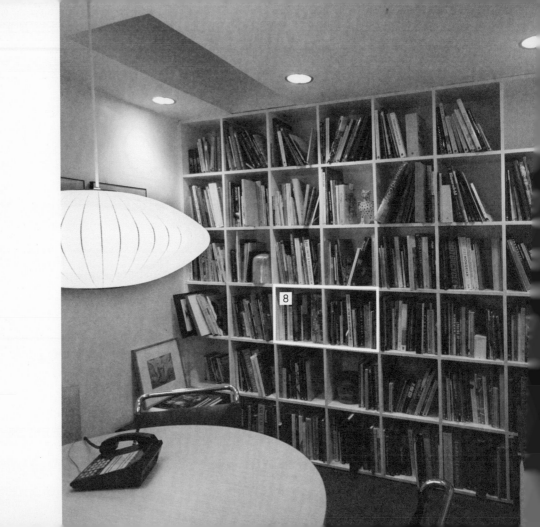

Urban Center Books: Your book *Work Life* describes Billie reading fiction, not architecture. Given the books on your shelves by such writers as Vladimir Nabokov and M. F. K. Fisher, could we push this to the extreme and say that work, life, and books encapsulate the sensibility of your practice?

Tod Williams + Billie Tsien: We would say that books are a part of life—but not the equivalent. Our work is enriched by the stories we read, and the stories we live, and the stories we see.

BT: I am a wanton reader—as long as it is fiction. In many ways it is an addiction because I always need to have my backup book and a backup of my backup. So I can't say that I am a collector, because the buying is not consciously driven. There is a secondhand bookstore I go to on Cape Cod. Since many writers and academics live there in the summer, the pickings are of an elevated sort. Often there are review copies that have never been reviewed but simply sold off in batches. As much as I look for known or favorite authors, I also like

to find new people. When I like an author's work a lot, I read everything he or she has written. Often authors don't write fast enough—or, worse, they are dead! So I love finding the review books, because their authors are generally unknown and thus I can start a whole new path.

I think that Nabokov and Fisher influence my work and teaching. There is such a strong emphasis on the power of the senses both to instill memory and to stimulate emotion. I would like our work to be able to do this for people in a subtle but intense way. When I teach, I ask students to try to find this direct sensuous experience in their work.

TW: I am collector and a hoarder, not only of books but of all kinds of treasures; they, and so many objects, are similar in the way they all hold life. The stone that seemed so alive when taken from the sweep of the seashore, the first book of one's childhood, that scrap of a sketch emitting a sense of comfort, the painting that touches one's soul, photographs piled in boxes under the bed, a message book, maps, even pencils and pens can convey more than they are. Even though I am not able to give them the attention they deserve (a complaint leveled by my mother, who tossed out dolls, toys, books, and even the dog), I am unwilling to give them up.

Each, holding the promise of a story, patiently waits to be pulled from the shelf, turned in the hand, and carefully examined. Only then are their rough-shaped memories polished by touch and brought to life by the imagination. While some are articulate and simple, most are far more opaque, secretive, and not readily clear. No doubt, most have far more power than they should. Why does a simple book of one's childhood command the respect of a revered novel?

Home and studio have been together, or some five hundred feet apart, for thirty-five years. Today's home was both home and studio for a number of those years, so drawers that held pencils and trace now hold socks, underwear, T-shirts, and occasional stray pencils. I have painted the dining table, a solid core door on round restaurant bases, twice: first thirty-five years ago and again some twenty

years ago. I still tape drawings to its surface, write directly on the hard white Swedish enamel that is so well preserved (most likely because of its lead content). A few days later it is scrubbed clean again. This morning our breakfast shares the surface with yesterday's mail, five books, a handful of pens and pencils, a roll of tape, another of trace, and of course, the *New York Times*.

We ascend eight rungs to where we sleep in a loft, a platform under the skylight. This morning when I awoke, I counted fifty-seven books stacked beside the bed. The majority are Billie's. I read so slowly that there may be only fifteen to twenty books a year that I fully enter and absorb cover to cover. They are all fiction or nonfiction, read at home in the mornings or evenings, on weekends and traveling. Books on architecture, art, and landscape are examined intensely, though never read whole. Those that find their way home are slowly returned to the library in our studio, which is a place of many activities, from meetings to model making to photography and, on occasion, sleeping. Rarely will I pick up a book on architecture when at home in the evening. This is my time for reflection, exploring, and getting lost in the stories.

I prefer either a simple and pure space or to be surrounded by many things of meaning and mystery, the rich strangeness of another world. The books at home are surrounded by objects. There is little order, except for size and (in the case of the objects) a visual order. Since space is limited, numerous photographs and smaller things are kept in boxes and drawers. In a way, the same is true for books. Whether they are visible or set two deep and tucked from sight, I am thankful for book covers because pages are naturally leaved inside, and some books tucked far enough from sight can't call too loudly. Otherwise the din would be unbearable. I am comforted with these things close by, extremely reluctant to organize them, yet pleased when they are in order. Once they are gone, I feel the loss and sometimes complain but never mourn.

No wonder I keep books in their place.

We have found the *Encyclopaedia Britannica* on several architects' shelves. Do you suppose that "raw" information

Architecture Library

Williams & Tsien	Williams & Tsien	Williams & Tsien
Williams & Tsien	Williams & Tsien	Williams & Tsien
Architectural History	Architectural History	Architectural History
General Architecture	Monographs (A)	Monographs (A–B)

Monographs (B)	Monographs (C–D)	Monographs (E–G)	Monographs (G)	Monographs (G–H)	Monographs (H–J)	Monographs (K)	Monographs (K–L)	Monographs (Le)	Monographs (Le)	Monographs (L)
Monographs (M)	Monographs (M–N)	Monographs (O–P)	Monographs (R–S)	Monographs (S)	Monographs (S)	Monographs (T–U)	Monographs (W)	Monographs (X–Z)	USA Architecture	USA Architecture
USA Architecture	USA Architecture	USA Architecture	International	International	International	International	International	International	International	Typology
Typology	Typology	Construction	Construction	Construction	Design	Design	Design	Journals	Catalogs	Catalogs

Art Library

Landscape (A)	Landscape (B–E)	Landscape (G–I)	Landscape (J–M)	Landscape (N–R)	Landscape (S–Z)	
Art (A)	Art (B)	Art (C)	Art (C)	Art (D)	Art (E)	Art (F–G)
Art (H–I)	Art (J)	Art (K)	Art (L)	Art (M)	Art (M)	Art (N)
Art (O)	Art (P–Q)	Art (R)	Art (S)	Art (T)	Art (U–Z)	Art Collections
Movies	Art History	Art History	Art History	Art Theory & Crit.	Art Journals/Catalogs	Oversize Art
Jewelry	African Art	American Art	Americas/Native	China	Japan–Z Art	Oversize Art

Travel Guides/Architecture Annex

Travel Guides	Travel Guides
Travel Guides	Travel Guides
Travel Guides	Travel Guides (USA)
Theory & Criticism	Theory & Criticism
Theory & Criticism	Travel Guides Oversize
Urban/Planning	Urban/Planning

Architecture Library	*Alphabetical by*
Williams & Tsien	Title
Architectural History	Title
General Architecture	Title
Monographs	Arch. last name/firm
USA Architecture	State
International	Country
Typology (building & structure types)	Title
Construction (materials & process)	Title
Design (includes furniture & graphics)	Title
Journals	Title
Catalogs	Title

Art Library	*Alphabetical by*
Landscape	Title
Art (monographs)	Artist last name
Art Collections (museums, private)	Collection name
Movies	Title
Art History (by movement)	Movement
Art Theory & Criticism	Title
Art Journals & Catalogs	Title
Oversize Art	Title
Jewelry	Title
Art International	Country

Travel Guides/Architecture Annex	*Alphabetical by*
Travel Guides	Country/US State
Theory & Criticism	Title
Urban/Planning	Title

is part of the equation of doing architecture? One might guess that an enormous appetite for knowledge of all kinds—of the world—is the key here. For example, we see a lot of books on Africa on your shelves.

TW + BT: Tod in particular is inspired by simple new (and old) knowledge that could be considered raw—that is, by facts. Billie is inspired by knowledge that is less complete—more fleeting—images and tales.

We have to ask about Louis Kahn. Could your project at the Salk Institute have been an homage to him? When tackling such a gift as this project, how do you proceed? Clearly you must have "read" Kahn upside down and backward.

TW + BT: Our project, the Neurosciences Institute, is actually a mile away from the Salk and is a part of the Scripps Research Institute. And while we were very aware of Kahn's great work, we did not see our work as either a homage or a challenge, but more as a partnership. We wanted our work to be in relationship to the Salk building.

Your urban residential work often takes a very, very expansive turn. The 1995 townhouse in New York City is almost an art gallery or, if you will, a mini-MoMA. How did this extraordinary spatial and complex textural synthesis come about? It's almost as if there are layers of embedded inspirations here, including manifestoes of modern or contemporary art.

TW + BT: There are embedded layers, but they are not theory based or manifesto based. They are always based on physical experience, emotion, and materials.

Would you tell us a bit more about the selection of titles on your top ten list?

BT: Nabakov's *Speak, Memory* reflects the power of the senses—touch, smell, taste—to bring you to your knees. M. F. K. Fisher teaches what is important in life. Virginia Woolf, in *To the Lighthouse,* describes the sense of time passing—sometimes slowly and silently (dust motes floating and sifting in the sun, things quietly falling apart), sometimes with

incredible speed in a way that is deeply shocking. Mrs. Ramsay dies and disappears within the space of two parentheses. Life feels like that.

When I finished architecture school, I moved to New York and began looking for a job in August. It was hot and sticky and the subways had no air conditioning. I would get on the subway to go for interviews in midtown. I was anxious and nervous and I would start to read William Faulkner's *Light in August*. When I looked up I was at 125th Street. This happened at least three times. It is a book that takes you away and slows down time to the way that time felt in Mississippi.

Harold and the Purple Crayon is the ultimate dream of architecture—you can draw your world the way you want it to be.

TW: My beloved encyclopedia, the eleventh edition of the *Britannica,* was purchased in a yard sale some thirty years ago. With the leather bindings now turning to dust, it's a chore to keep each volume in its place. I used to visit them more often but can now look things up more easily on the Internet.

Even so, it is without the pleasure and the intense diversion of the thin pages of the eleventh. Try looking up that crossword challenge: "river 40 miles southwest of Michigan City" (vol. HUS–ITA). Soon you are caught in a world you never expected to visit, and you return more than fifteen minutes later, having been through the inner workings of a Hydromedusa, on your way past India, through Hyderabad, en route to Indiana's Tippecanoe.

Novels and memoirs can be tempting in other ways too, like Annie Dillard's *The Living,* which lures me to live in the mighty stump of a Douglas fir, where I find myself moss covered, happily eating her heavy pages. Even more powerful are the emotions these books can conjure, like Joan Didion's *Year of Magical Thinking,* which seemed thin and innocent, until I entered.

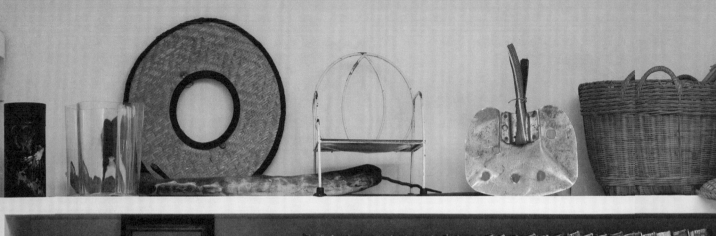

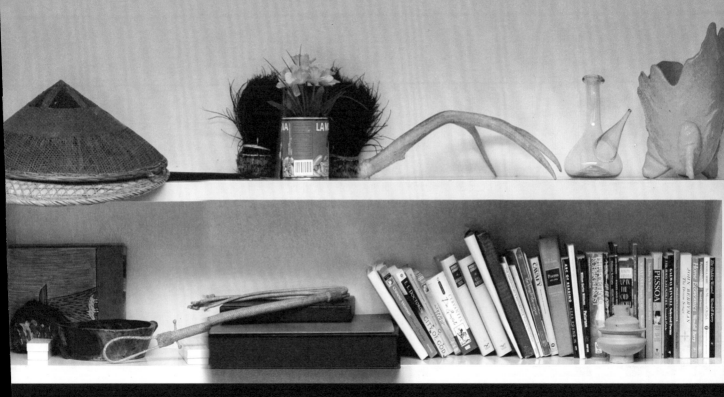

3

4

CONFLUENCE

LOOMIS CHAFFEE PHOTO BOOK & DIRECTORY

BLACKBOOK

Progressive Culture

Fieldglass 1999

TRIM
ALEXANDER BESHER

FIELDGLASS 1997
Breaking Time
a retrospective of the past 100 years

Harper Prom

Vol. 70

PYRAMID
MACAULAY

THE TWELVE TASKS OF ASTERIX

ASTERIX THE GAUL

GOSCINNY AND UDERZO

"Of Shadows Remembered . . ."

Fieldglass 1998

SPEAK CHINESE

SELECTED LETTERS 1902–1926
RAINER MARIA RILKE

TIM ROBINSON
MY TIME IN SPACE

DAVID LAMBERT
THE HANGING TREE

Waiting
HA JIN

The Human Stain PHILIP ROTH

AFRICAN LAUGHTER DORIS LESSING

"Once More With Joy"

A WIDOW FOR ONE YEAR
JOHN IRVING

CHARLES VAN DOREN
A HISTORY OF KNOWLEDGE
Past, Present, and Future

AMBROSE
LEWIS & CLARK
ABELL

Wallace Stegner
COLLECTED STORIES

RANDOM HOUSE

Tom Sachs
Nutsy's Deutsche Guggenheim

ART AND SCIENCE

5

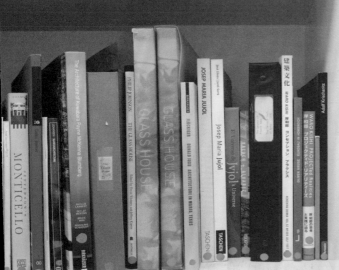

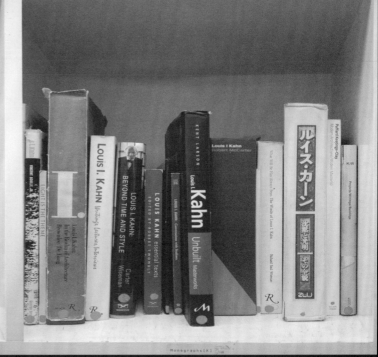

Top Ten Books

**Tod Williams
and Billie Tsien**

Joan Didion
*The Year of
Magical Thinking*

Annie Dillard
The Living

*Encyclopaedia
Britannica,*
Eleventh Edition

William Faulkner
Light in August

M. F. K. Fisher
Serve It Forth

Hardie Gramatky
Creeper's Jeep

Crockett Johnson
*Harold and the
Purple Crayon*

Herman Melville
Moby-Dick

Vladimir Nabokov
Speak, Memory

Virginia Woolf
To the Lighthouse

JOAN DIDION

THE YEAR OF

MAGICAL

THINKING

THE LIVING
A NOVEL

ANNIE DILLARD

THE ENCYCLOPÆDIA BRITANNICA

ELEVENTH EDITION

LIGHT in AUGUST
WILLIAM FAULKNER
author of SANCTUARY

MFK Fisher

SERVE IT
FORTH

Creeper's Jeep

by
HARDIE GRAMATKY
author of LITTLE TOOT

HAROLD
and the
PURPLE
CRAYON

by
Crockett
Johnson

MOBY
DICK

VLADIMIR NABOKOV

"in our time."—New Republic

"The finest autobiography written

speak, memory

An Autobiography Revisited

INTERNATIONAL

Virginia Woolf

TO THE LIGHTHOUSE

EVERYMAN'S LIBRARY

Contributors

Stan Allen was educated at Brown University, the Cooper Union, and Princeton University. He is principal of Stan Allen Architect, founded in 1980, and dean of the School of Architecture at Princeton University.

Henry N. Cobb is one of three founding principals of Pei Cobb Freed & Partners. He received a master of architecture from the Harvard Graduate School of Design. From 1980 to 1985 he served as studio professor of architecture and urban design and as chairman of the Department of Architecture at the Harvard Graduate School of Design, where he continues to teach occasionally as a visiting lecturer.

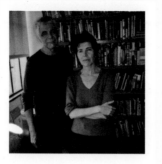

Liz Diller and Ric Scofidio founded D + S in 1979. Elizabeth Diller received a bachelor of architecture from the Cooper Union School of Architecture and is a professor of architecture at Princeton University. Ricardo Scofidio attended the Cooper Union School of Architecture and received a bachelor of architecture from Columbia University. He is professor emeritus at the Cooper Union School of Architecture.

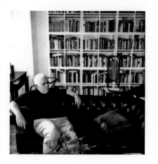

Peter Eisenman is the principal of Eisenman Architects, founded in New York in 1980. He received a bachelor of architecture from Cornell University; a master of architecture from Columbia University's Graduate School of Architecture, Planning and Preservation; and MA and PhD degrees from the University of Cambridge. He holds the Louis I. Kahn Visiting Professorship of Architectural Design at Yale University.

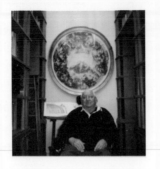

Michael Graves founded his architecture and design practice in Princeton, New Jersey, in 1964. He is the Robert Schirmer Professor of Architecture, Emeritus, at Princeton University, where he taught for forty years.

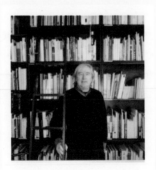

Steven Holl received a bachelor's degree from the University of Washington and pursued his architecture studies in Rome. In 1976 he established Steven Holl Architects in New York City. He is a professor at Columbia University's Graduate School of Architecture, Planning and Preservation.

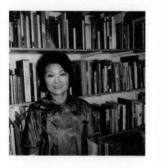

Toshiko Mori is the Robert P. Hubbard Professor in the Practice of Architecture and was the chair of the Department of Architecture at the Harvard Graduate School of Design from 2002 to 2008. Mori earned a bachelor of architecture from the Cooper Union and an honorary master of architecture from Harvard University. She established Toshiko Mori Architect in New York City in 1981.

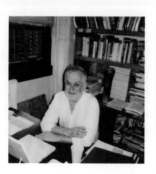

Michael Sorkin received his architectural training at Harvard and MIT, and in 1977 he founded Michael Sorkin Studio. He is Distinguished Professor of Architecture and director of the graduate program in urban design at the City College of New York.

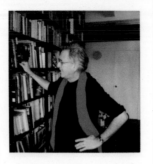

Bernard Tschumi received his architecture degree at the Federal Institute of Technology (ETH), in Zurich, Switzerland. Bernard Tschumi Architects, based in New York and Paris, opened in 1983. Tschumi was dean of the Graduate School of Architecture, Planning and Preservation at Columbia University from 1988 to 2003.

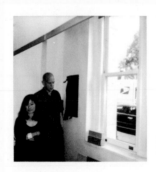

Tod Williams and Billie Tsien have worked together since 1977, and they formed a partnership in 1986. They share the Louis I. Kahn Visiting Professorship of Architectural Design at Yale University. Tod Williams studied architecture at Cambridge University and received a master of fine arts and architecture from Princeton University. Billie Tsien received a bachelor of fine arts from Yale University and a master of architecture from the University of California at Los Angeles.

Yale University Press
P.O. Box 209040
New Haven, CT 06520-9040
yalebooks.com

Urban Center Books
457 Madison Avenue
New York, NY 10022
urbancenterbooks.org

In 1980 the Municipal Art Society of New
York opened Urban Center Books with the
support of the J. M. Kaplan Fund. Founded
in 1893, MAS is a nonprofit membership
organization that fights for intelligent
urban design, planning, and preservation
through education, dialogue, and advocacy.
mas.org.

Library of Congress Cataloging-in-
Publication Data

Unpacking my library: architects and their
books / edited by Jo Steffens ; featuring
an essay by Walter Benjamin. p. cm.
ISBN 978-0-300-15893-9 (hardcover: alk.
paper) 1. Architects — Books and reading.
2. Best books. I. Steffens, Jo.
II. Benjamin, Walter, 1892–1940.
NA2597.U56 2009
720.92'2 — dc22
2009020150

Grateful thanks are offered to the
following people: Joseph Bedford, Barry
Bergdoll, Michael Bierut, David Childs,
Vin Cipola, Joan Spaulding Cobb, Beatriz
Colomina, Jay Cosgrove, Binh Dang,
Cynthia Davidson, Joan K. Davidson, Keller
Easterling, Peter Eisenman, Jhaelen Eli,
Octavia Giovannini-Torelli, Kitty Hawkes,
Julia van den Hout, Ann Kirschner, Michelle
Komie, Paul LeClerc, Peter Leech, Minxia
Lin, Katie Linker, Alberto Manguel, Mary
Kate Murray, Louise Pan, Ben Saltzman,
David Schnakenberg, Adena Siegel,
Colin Spoelman, Lisa Su, Jean Tatge, Lexi
Tsien-Shiang, Jenya Weinreb, Ken Wong,
Christina Yang.